MW00453620

Threads of Faith

Threads of Faith

RECENT WORKS FROM
THE WOMEN OF
COLOR QUILTERS NETWORK

■ ■ ■

Patricia C. Pongracz, Editor

*With contributions by Carolyn Mazloomi
and Patricia C. Pongracz*

This catalog accompanies the exhibition
*Threads of Faith: Recent Works from the
Women of Color Quilters Network,*
on display from January 23–April 17, 2004.

The Gallery at the American Bible Society
1865 Broadway (at 61st Street)
New York, New York 10023

The exhibition was curated by Carolyn Mazloomi,
founder of the Women of Color Quilters Network,
and Patricia C. Pongracz, Curator,
The Gallery at the American Bible Society.

CONTRIBUTING EDITOR Kenneth Benson
CATALOG DESIGN Kara van Woerden
EXHIBITION DESIGN Tom Moran
PHOTOGRAPHY Gina Fuentes-Walker
PRINTING The Stinehour Press, Lunenburg, Vermont

All biblical quotations (except in the artists' statements)
are taken from the *Good News Bible: Today's English Version,*
New York: American Bible Society, 1992.

Catalog published by the The Gallery at the American Bible Society.

©2004 The Gallery at the American Bible Society
Item 113019
ISBN 1–58516–773–8

Table of Contents

■ Foreword

Quiltmaking is, for certain African American communities, more than just one of the most popular art forms today. It is a connection with their history and an affirmation of creative identity; a way of to record history and a means to forge the future. The diversity of this creative universe is apparent in the styles, techniques, and approaches to subject matter of individual quilts, as well as in the profiles of individual artists. The exhibition *Threads of Faith: Recent Works from the Women of Color Quilters Network* is a glimpse into that universe.

While *Threads of Faith* finds its place in a series of recent exhibitions showcasing the richness of African American quiltmaking traditions, it is unique in its focus on the role of the Christian faith in the lives of the artists, the creative process, and the quilts themselves. The works in the exhibition attest to the many different ways in which faith can touch an artist, and in turn be spoken about and artistically expressed.

An exhibition is the work of many people over time: it is the result of collective vision, talent, dedication, and hard work. Our gratitude goes to Carolyn Mazloomi and the members of the Women of Color Quilters Network. Without their knowledge and artistry the richness you see in the exhibition and in the pages of this catalog would have been impossible.

The exhibition took shape in the capable hands of the staff of The Gallery at the American Bible Society. My special thanks go to all of them. I am particularly grateful to Patricia Pongracz, co-curator of the exhibition, for her intellectual curiosity, sensitivity, and dedication to educating us and our constituents. Ute Schmid made sure that the installation went smoothly, according to plan, and on budget, and shepherded the book from manuscript to printed volume. Kim Aycox assisted with both gathering information from the artists and the installation process. Gallery intern Megan Whitman, Oberlin College, became an invaluable research assistant. Exhibition designer Thomas Moran turned a list of quilts into a stunning installation, while Kara van Woerden gave superb graphic identity to both the installation and the catalog. Gina Fuentes Walker's skill as a photographer ensured that the images of the quilts reproduced in this catalog do justice to the originals. Kenneth Benson added elegance to the text of this volume and improved its factual accuracy.

As a museum dedicated to exploring the rich legacy of the Scriptures in Judeo-Christian art throughout the centuries, The Gallery at the American Bible Society is pleased and proud to present *Threads of Faith*. We dedicate it to all African American quilters, and we hope that it will educate and inspire all our visitors.

ENA G. HELLER
Director, The Gallery at the American Bible Society

■ Acknowledgments

Three years ago two women had a vision of a fabulous quilt exhibition being held in the most wonderful gallery space in NYC. *Threads of Faith* and the accompanying catalog would not have happened without the initiative taken by Peggie Hartwell and Esperanza Martinez, who approached The Gallery at the American Bible Society with the idea of an exhibition of quilts made by members of the Women of Color Quilters Network. I am indebted to both of you.

To Dr. Ena Heller and Dr. Patricia Pongracz, I give special thanks for giving the Network the opportunity to exhibit its members' quilts, for the sensitivity and respect given to the artists and their work, and for their willingness to let the unfettered voices of the artists be heard. To my co-curator, Dr. Patricia Pongracz: we met as strangers and I have come away with a new sisterfriend. I am profoundly grateful to Gallery staff members Ute Schmid, Kim Aycox, and Mavis Vann for their assistance, patience, and support.

This book would have been impossible without the talent of the Women of Color Quilters Network artists, modern day griots who continue to record the stories of our people in cloth. Your creativity never ceases to amaze me.

I am deeply indebted to my research assistant, Denise Campbell, for her support and belief in my work through words and deeds. It hank my dear friend Dr. Beverly Guy-Sheftall for her help and encouragement, and for always believing I can do the impossible. To my friend and mentor, the late Marie Wilson, your spirit will always surround all I do.

I reserve special thanks for my husband Rezvan Mazloomi, the most spiritual being I know, for his patience and support.

Finally, I give thanks to the ancestors who walk this creative journey with me.

CAROLYN MAZLOOMI,
West Chester, Ohio

Introduction

1 For African American quilting traditions, see Cuesta Benberry, *Always There: The African-American Presence in American Quilts*, Louisville, KY: Kentucky Quilt Project, 1992; and Gladys-Marie Fry, *Stitched from the Soul: Slave Quilts from the Antebellum South*, Chapel Hill: University of North Carolina Press, 2002. For aesthetic traditions attributed to African American folk artists, see: Maude Southwell Wahlman, *Signs & Symbols: African Images in African American Quilts*, Atlanta, GA: Tinwood, 2001. For individual quilters, see Roland L. Freeman, *A Communion of the Spirits: African-American Quilters, Preservers, and Their Stories*, Nashville, TN: Rutledge Hill Press, 1996.

2 For the most recent annotated bibliography of African American quilting see Kyra E. Hicks, *Black Threads: An African American Quilting Sourcebook*, Jefferson, NC: McFarland & Co., 2003; for a comprehensive list of exhibitions to date, pp. 38–46.

3 A point highlighted by the recent reprinting of Wahlman's *Signs & Symbols,* first published in 1993, and the exhibition *The Quilts of Gee's Bend,* organized by the Museum of Fine Arts, Houston (September–November 2002). See John Beardsley, et al., *The Quilts of Gee's Bend*, Atlanta, GA: Tinwood Books, 2002; and John Beardsley, et al., *Gee's Bend: The Women and Their Quilts*, Atlanta, GA: Tinwood Books, 2002.

4 For the historiography, see Benberry, *Always There*, 13–16; Eva Unger Grudin, *Stitching Memories: African-American Story Quilts*, Williamstown, MA: Williams College Museum of Art, 1990: 7–13; and the very personal narrative in Freeman, *A Communion of the Spirits*, 116–122. For an excellent summary of the development of the polarities in the scholarship, see Jennie Chinn, "African American Quiltmaking Traditions: Some Assumptions Reviewed," in Barbara Brackman, et al., *Kansas Quilts & Quilters,* Lawrence, KA: University of Kansas Press, 1993, especially 157–165. The diversity of African American quilters has been noted by: Benberry, *Always There*, 16; Fry, *Stitched from the Soul*, 10; Grudin, *Stitching Memories*, 10; and Faith Ringgold, in her preface to Carolyn Mazloomi, *Spirits of the Cloth: Contemporary African-American Quilts*, New York: Clarkson Potter/Publishers, 1998, 8; Chinn, "African American Quiltmaking Traditions," 173–175.

5 For the founding of the WCQN, see Sandra K. German, "Surfacing: The Inevitable Rise of the Women of Color Quilters' [sic] Network," Uncoverings, vol. 14 (1993), 137–168, especially 150–167; Freeman, *A Communion of the Spirits*, 59–60; and Mazloomi, *Spirits of the Cloth*, 13–14.

Over the course of the last 30 years, there has been sustained interest in the study of quilts made by African Americans. Scholars, as well as those actively practicing this traditional art form, have written studies documenting the histories and aesthetic traditions of African American quilts, while also collecting the stories of the quilters and organizing exhibitions of their work.[1] A survey of the vast literature on African American quiltmaking confirms that the richness of the field lies in the diversity of both the artists and the quilts that they have been producing in the United States for more than 200 years.[2] However, individual books and exhibitions can only hope to tell a small part of the story, examining specific works and tracing their inspirations, for quilts produced by African American artists are as varied as their makers.

The characteristics of African American quilts vary widely according to who defines both the terms and the type of quilt that is in mind. One dominant image perpetuated by some scholars is that of the non-narrative bed covering produced by a poor and uneducated woman from the rural South.[3] To be sure, quilts fitting this description continue to be made and they are a more than worthy subject of study. But as the quilts on display in *Threads of Faith: Recent Works from the Women of Color Quilters Network* demonstrate abundantly, quilts that do not fit such narrow parameters are produced in equal numbers – a point made by African American quilters and quilt scholars alike.[4]

The significance of this point led Carolyn Mazloomi to found the Women of Color Quilters Network (WCQN) in 1985, in the hope of creating a community of African American quilters living and working throughout the United States. Having felt increasingly isolated in the quilting community at large, Mazloomi placed a call for correspondence to other African American quilters in the *Quilters Newsletter Magazine* of August 1985. Her request elicited eight responses, and this was the seed of the WCQN.[5] The WCQN was established to promote, record, and protect the diverse legacy of African American quilters and their quilts, and to provide a forum for the open exchange of information among its

members. Now over 1700 members strong, the Network is notable for its diversity: members range in age from their mid-thirties to 96 years old, and they come from a range of socio-economic, ethnic, and educational backgrounds – and not all are women. In spite of such differences, the membership is united by its commitment to quilting and to the search for community.

■ Threads of Faith

Threads of Faith examines contemporary African American quilts produced by a community that is inspired by faith, the Bible, and America's Christian traditions. The 53 quilts on display, the work of 33 members of the Women of Color Quilters Network, testify to the continuously responsive nature of this traditional craft.[6] In the hands of WCQN members, quilts record personal histories, make political statements, and celebrate family values, while also reflecting the role of faith and Christian tradition in a shared history, regardless of individual religious beliefs. For these African American artists, faith, whether practiced actively or not, connects them both to their individual pasts and to their collective legacy.

In her essay "Threads of Faith," Carolyn Mazloomi broadly explores the role of faith in the African American community and its inevitable impact on contemporary quilting. In the entries that follow, the quilts have been divided into five thematic categories: biblical narratives (Sacred Moments: From Scripture to Cloth), women and family (Bearing Witness), prayers and spiritual meditations (Hope: The Anchor of Our Souls), worship through the arts (Blessed are the Piece Makers), and the African American experience (We Have Come This Far by Faith). These sections capture the varied individual perceptions of and responses to the role of faith in the world at large. Each entry contains an artist's statement and a selective curriculum vitae, which gives a sense of each quilter's background. When read together, the entries reveal the diversity of this particular group of artists – a diversity mirroring that of the larger African American quilting community.

Intrinsic to any study of African American quilts is the notion of voice, both individual and collective. Over the course of the last year and a half, I have asked the artists to explain not only the significance of their quilts, which they have done in their artist statements, but also to expand on the role quilting plays in their lives. In phone conversations, emails, and questionnaires, they have spoken about the particulars of their individual creative processes (how they learned to quilt, when and why they began, how they conceptualize a quilt), as well as eloquently expressing what quilting means to them. For these artists, quilts simultaneously embody and illustrate African American heritage and the faith that is indivisible from it. The portrait that has emerged is consistent with that

6 Working with Dr. Carolyn Mazloomi, Founder and President, Women of Color Quilters Network, The Gallery at the American Bible Society put out a call in the Spring of 2002 to members of the Network interested in displaying works inspired by the Bible, Christian tradition, and faith. The 53 works were selected from approximately 90 responses.

of any group of engaged, articulate artists striving to understand and define their perceptions of the world. It is a portrait that defies broad categorization, confounding the stereotypes of black quilts and their makers that have been defined over the last 30 years, and which continue to be perpetuated. While *Threads of Faith* joins a long line of distinguished exhibitions that have sought to offer a glimpse of the variety of African American quilts, it is the first to focus solely on the role of faith and America's Christian traditions in African American quiltmaking.[7]

This exhibition has been structured so that the quilts are seen within the contexts of their makers' lives, the African American quilting community, and – more broadly – the march of American history. Although the quilts are the focus of the exhibition, I have also emphasized the artists' voices in an effort to dispel the all-too-often pejorative notion of the "African American Quilt Style."

Although each quilt can be viewed as a unique expression of its maker, taken together, these 53 works of art respond to and add to a rich cultural heritage. Whether comforting, confrontational, political, religious, familiar, or foreign (or some combination thereof), these quilts educate, celebrate, challenge, and commemorate. The quilters translate narrative into fabrics, using colors, patterns, and sewing techniques to make a connection with the viewer. The quilts, resonant with personal experience, become a voice offering insights into the issues of race, faith, class, education, artistry, the African American experience, and American history.

What follows is a narrative, in the artists' own words, reflecting on the importance of having a voice, on the role that faith plays in their quiltmaking, and on the importance of the community that fosters their work. Their voices deserve careful and deliberate consideration, for they have much to offer to all of us.

■ Making a Statement: Having a Voice

The members of the WCQN are no different from other artists in that their work is informed by personal experience; as artists, they respond to aesthetic traditions, as well as to historical and contemporary events that are of particular interest to them. Inspiration for the quilts on display in *Threads of Faith* ranges from life as a black woman in the United States to cultural heritage and its celebration and preservation, to the role of faith. All of the artists write of quilting as a means of self-expression, which naturally takes many wondrously various forms.

Artists like Gwendolyn Magee (entries 44, 45) and Kyra E. Hicks (entries 31, 32) write that their subjects are often drawn from their life experiences as African American women. Barbara G. Pietila notes that although all of her quilts are "about some aspect of African American life," *Color Him Father* (entry 19) was a conscious attempt to educate the public

7 See, for example: Grudin, *Stitching Memories*, 1990; Benberry, *Always There*, 1992; Mazloomi, *Spirits of the Cloth*, 1998; and those exhibitions organized in conjunction with the Women of Color Quilters Network listed in footnote 10 below.

about African Americans. Through the positive images of everyday fatherhood, she hoped to show "That we as a people live lives much like everyone else in this country. That we are not a race of drug dealers and prostitutes." Pietila believes that a quilt is the ideal medium to express the universals of human experience. "I find," she writes, "that people like and respond to my subject matter and to color. I like seeing them smile and point to things they relate to."

Other artists ardently tackle political subjects. Marla Jackson (entries 20, 49) writes that she wants "to challenge people to look at uncomfortable subjects ... in the hopes of enlighten[ing] viewers." This effort to express and educate viewers about historic African American experiences drives many of the quilters to research their subjects in depth. For example, L'Merchie Frazier's *Jubilation: Is Freedom Visible?* (entry 46) illustrates crucial events in the history of African American emancipation. She wants viewers of her quilts to remember ...

that we are engaged in a conversation about the subject, that our discussion and conversation were accessible because of the quilt. It is my desire that there is a sense of retooling, spiritual renewal and redemption discussed in these works, and the quilt gives the forum for contemplation of issues that might otherwise be avoided.

To that end, she encourages dialogue in the very structure of the work, by including pockets on the quilt in which viewers are urged to tuck their thoughts by writing them on small pieces of paper provided in the installation.

Still, other quilters like Zene Peer (entry 33) speak of creating narratives that "are anchored in ancestry and history." Many artists express the feeling of a palpable connection to the past as they quilt. This is perhaps due in part to the fact that stitching fabric into quilted narratives inevitably taps into the long history of a traditional craft, and because the narratives many choose to create celebrate African American legacies. As Kyra E. Hicks notes, "my quilts are not just contemporary, but in fact are a part of a tradition of religious quilts by black Americans like Harriet Powers."

In addition to continuing a tradition, artists like Theresa Polley-Shellcroft (entries 8, 26) describe a transcendence that the act of quilting allows. As she has put it ...

Quilts transport me in time to the hands and spirits of my ancestors. They are prayer cloths that are like books, lines of words, notes of music, Luba memory boards. They tell stories, my stories, in colors and patterns ... my work is the continuing of the expression of my ancestors, who guide me and have set examples for me to follow as I must set an example for my son and others who follow me.

The notion of quilting as an act important to ancestors and descendants alike is expressed by many of the artists. Cynthia H. Catlin (entries 7, 35) views quilting not only as a celebration of the past, but also as the creation of a legacy for the future, one she wants the public to see in exhibitions. She writes that quilting "is my voice and grants me the opportunity to express the topics that I am most passionate about. It is my legacy to future generations." Marlene O'Bryant-Seabrook (entry 11) voices a similar thought, writing that she considers her quilts, all of which are still in her possession, as "'legacies in fiber' for my married children and their families."

For all of the artists, the link between the past and future is ever present. They are well aware that fostering a legacy demands the education of future quilters, a point aptly stated by Myrah Brown Green (entries 13, 37): "I remember my ancestors as I work with a quilt. I also know that I have a responsibility to teach quiltmaking to the young so that the art will stay alive."

■ The Role of Faith in Quilt Making

Specific to *Threads of Faith* is the exploration of how faith informs the work of the artists. As Carolyn Mazloomi explores in her essay, faith, particularly in the American Protestant tradition, is central to understanding the African American community historically. For this particular group of artists, the role of faith in their work varies from the open embrace of Christian tradition and worship, to more general spiritual experiences without specific Christian affiliation.

Yvonne Wells (entries 14, 29, 30) expresses the notion held by many of the artists that faith, as an omnipresent component of her life, necessarily informs all of her work. She writes, "All subjects that I choose relate to my faith. No matter what the subject is you will find my trademark 'Trinity' on the back of the quilt. My art is learned from the gut, ignited by the soul and kept aflame by spirituality." Anita Knox (entry 16) underscores the notion of the indivisibility of faith from life and work. "I can't," she states, "separate myself from my art, and without faith I could not continue to make art."

Some artists write that their work is directly inspired by their Christian faith. Cynthia H. Catlin affirms that the "subjects I choose relate to Christianity and my belief in God. My faith is critical and essential to my creative process." Speaking to an active Christian devotion, Ed Johnetta Miller (entry 34) proclaims that "My faith is so strong, every morning when I arise I reach for my Bible, read a passage, thank God for being so good to me and allowing me to have another day to create." Similarly, Tina Williams Brewer (entry 27) describes how she often "discovers a topic while at Mass," noting that the quiet church service permits time for introspection. She characterizes her quilts as "based

on [her] Catholicism and rooted in African traditions," which inform one another.

Artists also write of their quilts as directly inspired by Christian liturgical practices. Trish Williams notes that the subject for her quilt *Dancers of Praise* (entry 38) was inspired by "a dance of praise," which she finds to be "a wonderful way to worship God." Williams writes that music performed in church, particularly gospel songs, also informs her work. Cleota Proctor Wilbekin's *Communion Robe and Cross* (entry 41) takes liturgical inspiration a step further in that it is designed for her minister as a vestment to be "worn just prior to the giving of bread and wine for the forgiveness of sins." She writes …

My faith in the Lutheran religion rests upon the hope of salvation and the forgiveness of sins all under His sacrifice on the cross one Friday and overcoming it all in the resurrection of our Savior. My faith is important to everything. This communion robe is indicative that I love the Lord.

Other artists describe how prayer is essential to their creative process. Gwendolyn Aqui (entry 15) states that she prays "before actually starting a quilt. Faith is an essential element in my life. God gives me the energy [to quilt]." Kyra E. Hicks, who also prays before quilting, writes that "I thank God for this gift, I hope I am using the gift well."

That artistic creativity is a "gift from God" is mentioned repeatedly by the artists. Cynthia H. Catlin, Zene Peer, Peggie Hartwell (entries 3, 4, 53), and Sherry Whetstone-McCall (entry 17) all speak of being compelled to use the creative talents that have been bestowed upon them by God. Other artists, like Diane Pryor-Holland (entries 21, 47), Cynthia Lockhart (entry 39), and Phyllis Stephens (entries 10, 43), speak of trust in God, to the idea that their work is divinely guided. Pryor-Holland writes that her two quilts in the exhibition "relate to faith and trusting God. My faith tells me with God, all things are possible. When I trust in God I can move mountains." Artist Michael Cummings (entries 9, 42) describes his creativity as a blessing …

I grew up in a Baptist church so Christ is a central figure. I believe in a spirit greater than man, I believe it is a blessing to be able to create and many a time, I am inspired by an interior feeling that guides my creativity.

For Denise M. Campbell (entry 48), quilting is

… a very spiritual and cathartic experience for me. It is one of the spiritual languages through God and I can communicate. I cannot recall making a quilt that was not divinely inspired or influenced.

The idea that creative expression is guided by an "interior feeling," or by "spirit" or faith, is also repeatedly invoked. Artist Adriene Cruz (entries 1, 2, 28) writes that for her, "All art is an act of faith – trusting that divine guidance will allow you to create something wonderful." Cathleen Richardson Bailey (entry 12), affirming the notion of "divine guidance," considers her work, regardless of subject, to be "spirit driven" ...

My quilts can be about lynching, domestic violence, making love, nature, or paying homage to traditional West African (Yoruba) spirituality. I consider creativity a gift from God. My work is spirit driven. I take myself out of it. It's not me. I'm being used. What is me is that I've developed my inner ear so that I can hear the Spirit. And then I follow instructions.

Theresa Polley-Shellcroft also attests to the idea of her work as "spirit driven," affirming that it is "very close to my faith and personal life." She observes that her quilts

... are very much reflections of my spirituality, because it is and has always been the spirit that guides my hand. Faith, the assurance of things unseen? Yes, faith is extremely important in my work and as a guide for my work as an artist, quilter or painter, mother, teacher, or friend ... I have always believed that my creative energy and expressions were not my conscious work, but those of the spirit. In this and of this, I must have faith.

In spite of the focus on faith in *Threads of Faith*, many of the artists are careful to emphasize that although their work in the exhibition illustrates expressions of faith, faith is but one of an array of themes in the larger body of their work. Of tackling biblical themes, Viola Burley Leak (entry 25) observes ...

In dealing with the Bible as subject matter for a quilt, the art of illustrating and projecting the meaning I want to convey requires the same command of a visual language as depicting any other topic. However, I find the Bible to be one of the most fascinating topics because all of life's issues are spoken of in this book. It is an endless reference. I do not always choose the Bible as my subject. I often switch to whatever presents itself in my life at the time.

Similarly, Michele David (entries 5, 6, 18) writes that although faith is important to her in that it "allows [her] to work and have courage to face life," her quilts are only occasionally inspired directly by faith.

Other artists do not make a conscious connection between their work and faith, but discover that some viewers of their quilts do. As Gwendolyn Magee writes ...

I make no direct connection between the subjects I choose (or rather those that choose me) and faith. However, working on the Lift Every Voice and Sing *series has become a true "journey of the spirit" for me. It has been extremely satisfying on a very personal, emotional level and it has been gratifying to learn that wherever works from the series are exhibited, that they have also struck a deep and responsive chord in others.*

Similarly, Alice Beasley (entry 50) states, "I am not religious, although I do believe that there are almost no social conundrums that cannot be solved by the Golden Rule."

Finally, many of the artists reveal that their art is rooted in a faith that provides stamina and hope in trying times, and that this enables them to create. Marla Jackson describes how for her …

Quilting is spiritual. The feeling is so deep and serene and peaceful. I know this feeling is a blessing from the Lord. He is with me every step through life's journey, especially in dark times.

Viola Burley Leak seconds the notion of faith enabling her to work through trying times …

First of all, I feel that to be an artist you have to have faith in yourself. Faith helps you to master your work and command the results you desire. To fight the good fight and make this possible is not easy. So, you pray to God to help you the rest of the way. Between your efforts and God you just might succeed. Whether it is quilting or another media in which I am working, the issue of belief and conquering trials is always there.

And Dindga McCannon (entries 22, 23, 40) sums up the importance of having faith this way …

In order to be an artist in a world that generally does not appreciate you, you have to have faith that what you're creating is God inspired and will go on and inspire others to see and to think.

■ A Portrait of a Community

Though the WQCN obviously shares an affinity for quilting, each member's reasons for why and what they create, and when they began to quilt, are rooted in differences in age and in individual perceptions and life experiences. Some quilters, like Viola Canady, who at 81 years is the oldest member to have her work on display (entries 51, 52), remember learning to quilt as children from older women in their family. Ms. Canady recalls that when she was young, quilts served a primarily utilitarian function; she

herself learned to quilt in order to make blankets for her family, but even then she "saw the beauty in what I was doing." Some quilters remember women family members quilting, but they have themselves taken quilting up later in life, learning the craft through both formal classes and informal quilting groups. Still others, like Michael Cummings, Adriene Cruz, and Dindga McCannon, quilt as professional artists. Regardless of why they quilt, all of the artists in *Threads of Faith* have spoken of the importance of the supportive community embodied by the WCQN.

Founded in 1985 in response to the isolation many African American quilters felt in traditional American quilting forums, the WCQN was preceded by some smaller, regional quilting groups in which members could share information and ideas. One group, the Daughters of Dorcas and Sons, was co-founded in Washington, DC in 1980 by Ms. Canady and the late Etta F. Portlock. Named for the seamstress Dorcas (mentioned in Acts 9.36–41), the group's members are primarily African American women who meet weekly to quilt.[8]

The perceived sense of isolation that is consistently voiced by WCQN members is due in part to the nature of American life. This group of artists is no less susceptible than any other to the dictates of career and family. Often a move from one place to another results in isolation, a point emphasized by Barbara G. Pietila, who joined the WCQN while living in Russia. Speaking about isolation in traditional American guilds, Gwendolyn Magee voices an experience that is shared by many of the artists, pointing out that for years she was the only African American in her guild. This was not a problem as long as her interest in quilting lay in traditional patterns; however, when her work became a personal expression rooted in her own cultural heritage, she recalls that she

... began to feel very culturally isolated and emotionally disconnected. I was starved for interaction about something more relevant than traditional patterns, Baltimore Albums, Sunbonnet Sues, and the latest fads in how to quick piece quilt tops. I wanted to create work that was an expression of my heritage. I wanted, and needed, a shared community with other African Americans who also were finding expression in this genre.

Many of the artists write of experiencing either a persistent sense of physical isolation (being the only African American in the room) or of cultural isolation (creating from a perspective with which no one else in the group can identify) before they joined the WCQN.

While many members have sought out the WCQN in response to advertisements in quilting magazines and newsletters (like the eight original founding members), just as many have been actively recruited. An equal number of artists, such as Sandy Benjamin-Hannibal (entry 36) and Frances Hare (entry 24), indicate that they were invited to join by

8 For the founding of the Daughters of Dorcas and Sons (including photographs and an interview with Viola Canady), see Freeman, *A Communion of the Spirits*, 174, 176–177.

Mazloomi, who saw their works in various regional galleries and made a point of contacting them. Such deliberate recruitment underscores the active role that the WCQN plays in establishing bonds among quilters, in spite of the challenges posed by geography. Regardless of how they came to the WCQN, members have all voiced the immediate sense they had of having become part of a community.

Cathleen Richardson Bailey recalls her initial call to the WCQN, in response to an advertisement in a quilting magazine, recalling the sense of ease and friendship in her first conversation with Mazloomi: "She talked to me like we were old friends. She gave me a lot of information about contacts and exhibitions. I couldn't believe her generosity." Gwendolyn Magee underscores the importance of community, writing "When I found the WCQN, it was like 'coming home.'" What artists "come home" to is a supportive, nurturing community that encourages self-expression rooted in cultural identity. L'Merchie Frazier emphasizes this point …

I was delighted and humbled by [Dr. Mazloomi's] invitation to be included in the company of African American women who are spiritually directed to link their cultural voices by participating in the African and American quilt aesthetic. I enjoy participating with women who choose the quintessential, female-identified medium of quilts to communicate their very powerful messages.

Many artists affirm that quilting as part of the WCQN community has enabled them to create from personal experience unapologetically. Theresa Polley-Shellcroft states the general consensus among the artists of the importance of having her voice as an African American woman, as it is expressed in her quilts, accepted unconditionally …

I joined the quilt guild of Los Angeles (associated with the Network) about 2000–01, because with them I found common interests, stories, cultural identity, and quilting purposes. I find this quilting community very supportive and a place where I can be part of the community and maintain my individuality without having to explain or justify my quilts.

Other quilters have remarked that in addition to fostering creative freedom, the WCQN has provided them with very real opportunities to exhibit their work. Ed Johnetta Miller comments that prior to joining the WCQN in 1989 …

… [a]s an African American quilt artist, there were very few opportunities to show my work. The Network helped pave a path for us in galleries and museums across the US.

Miller underscores a central goal of the WCQN's mission: to educate the general public about the diversity of quilts made by African Americans. As Mazloomi advocates, in order to publicize the breadth of African American quilt making, quilts illustrative of the various styles, techniques, and subjects must be publicly exhibited.[9] To date, the WCQN has participated in exhibitions at many institutions, including: the Columbus Museum of Art, Columbus, OH (1995); the Textile Museum of Canada, Toronto, Canada (1996); the American Craft Museum, New York, NY (1999); and the National Civil Rights Museum, Memphis, TN (2002) a fact reflected in the vitaes of the artists that are published with their entries.[10]

Regardless of subject matter, the art quilts produced by these artists are a form of communication intended to "inspire others to see and think." Designed to be hung on a wall for public display, the quilts in *Threads of Faith* illustrate the artists' desire to educate, connect, and communicate with others – goals championed by the Women of Color Quilters Network.

Patricia C. Pongracz,
New York, New York

All quotations from the artists cited above were drawn from a Gallery Questionnaire that was circulated in the Spring of 2003. Copies of the questionnaires are on file at both The Gallery at the American Bible Society and the Archives of the Women of Color Quilters Network. The artists are listed below with the dates that the questionnaires were completed.

9 Personal conversation with the author, December 9, 2003.

10 Past exhibitions have included: *A Spirit of Cloth: African American Fiber Artisans*, The National Afro-American Museum & Cultural Center, Wilberforce, OH, 1993; *In the Spirit of the Cloth*, Columbus Museum of Art, Columbus, OH, 1995; *This is Not a Poem, This is a Summer Quilt*, Textile Museum of Canada, Toronto, 1996; *Spirits of the Cloth: Contemporary Quilts by African American Artists*, which opened at the American Craft Museum, New York, NY, in 1999 and then traveled nationally to museums including the Blaffer Gallery, The Art Museum of the University of Houston, Houston, TX, 2000, and the Smithsonian Institution, Renwick Gallery, Washington, DC, 2001; *Finding Voice, Creating Vision*, National Civil Rights Museum, Memphis, TN, 2002.

Gwendolyn Aqui, May 12, 2003
Cathleen Richardson Bailey, June 3, 2003
Alice Beasley, October 1, 2003
Sandy Benjamin-Hannibal, November 29, 2003
Tina Williams Brewer, December 15, 2003
Denise M. Campbell, June 1, 2003
Viola Canady, June 6, 2003
Cynthia H. Catlin, June 5, 2003
Adriene Cruz, May 15, 2003
Michael Cummings, March 28, 2003
Michele David, June 3, 2003
L'Merchie Frazier, July 2003
Myrah Brown Green, June 16, 2003
Frances Hare, June 8, 2003
Peggie Hartwell, May 9, 2003
Kyra E. Hicks, May 31, 2003
Marla Jackson, May 12, 2003
Anita Knox, May 12, 2003
Viola Burley Leak, May 30, 2003

Cynthia Lockhart, June 20, 2003
Gwendolyn Magee, May 29, 2003
Dindga McCannon, May 14, 2003
Ed Johnetta Miller, June 18, 2003
Marlene O'Bryant-Seabrook, June 3, 2003
Zene Peer, June 7, 2003
Barbara G. Pietila, May 12, 2003
Theresa Polley-Shellcroft, May 10, 2003
Diane Pryor-Holland, May 23, 2003
Phyllis Stephens, May 28, 2003
Yvonne Wells, May 28, 2003
Sherry Whetstone-McCall, May 19, 2003
Cleota Proctor Wilbekin, May 27, 2003
Trish Williams, May 8, 2003

Threads of Faith

The books of the New Testament are rich with messages of hope – hope of righteousness by faith (Galatians 5:5), hope in the Lord Jesus Christ (Timothy 1:1), and hope as the anchor of our souls (Hebrews 6:19). Writer Alice Walker reflects on this hope by illuminating generations of spiritual creativity among ordinary African American women artists, including quilters. A quilter herself, Walker captures the essence of these journeys of hope, noting that through their works, it was not so much what African American foremothers sang as it was keeping alive "the notion of the song."[1] Equipped with fabric and thread, African American quilters historically have woven together personal songs of faith and the collective songs of hope.

The ingenious spiritual creativity of African American quiltmakers is reflected in the visual interpretations of individual journeys which collectively create a synergistic polyphony of spirituality. Just as Christians participate in praise and worship services and are moved in the depths of their souls to glorify God, many African American quilters honor their Lord and Savior in cloth through the quilting process. They stitch life into the fabric and images of their quilts through shared joys, sorrows, hopes, and testimonies. Each artist has planted seeds of faith with the talents of her/his hands, to create works that honor Him and minister to others. It is a spiritual calling. Every quilter becomes an intercessory prayer warrior. Every quilt becomes a prayer, a praise song, a testament to the goodness of God. As Denise M. Campbell conveys, "Quilters have long understood that when God heals us individually it is never intended for just one person; rather it is a call to use our healing as a comforting quilt that envelops and warms others in need."

Through quilts, the artists evoke the West African spiritual traditions of "Sankofa." That is to say, the quilter's spiritual journey requires that s/he "go back and fetch" in order to move forward. Quilters fetch messages from the Bible, retrieve lessons from cultural and personal experiences, and portray the hopes of ancestors long past. The quilter's hope lies in the faith that in so doing, a life will be touched, a broken heart healed, a soul drawn closer to salvation. Examples of these concepts can be found in the stories surrounding the quilts in the *Threads of Faith* exhibition.

1 Alice Walker, *In Search of Our Mothers' Gardens: Womanist Prose* (San Diego: Harcourt Brace Jovanovich, 1983), 231–43.

■ The Beginnings

No practice is more meaningful in the life of blacks, better illustrates the manner in which different streams of influence flow together, and better reflects the synthesis of an ancient heritage with the culture imposed by the masters than religion.
Wᴵʟʟᴵᴀᴍ S. Pᴏʟʟᴵᴛᴢᴇʀ, 1999

For centuries, peoples of African descent were subjected to the largest forced migration in human history as a result of the European slave trade. This involuntary journey of an estimated ten million Africans to the "New World" produced slave populations in the United States, the Caribbean, and Latin America. The communities transplanted by this profoundly disruptive process of dispersal would come to be known as the African Diaspora. Although some scholars continue to assume that African cultural traditions did not survive the trauma of the Middle Passage and the degradations of slavery, there are important elements of African American culture that are traceable to Africa in black music, dance, folk beliefs, worship rituals, burial rituals, and art. There are numerous manifestations of the ways in which African Americans have maintained a deep spiritual connection to their ancestral homeland.

Perhaps the most profound echoes of African culture throughout the Diaspora are to be found in religious tradition, creative expression, and spiritual values. An African belief in a Supreme Being (God, the Creator), a pantheon of lesser gods (intermediaries between God and humans), and the power of the spirit world, including ancestors, was present among blacks in Latin America, the Caribbean, and the United States, even after they had embraced Christianity. It is important to recall the religious traditions and value systems that enslaved Africans brought with them to the New World, including ancestor worship, respect for the elders, and animism (the idea that spiritual forces pervade all living things). Albert Raboteau, author of a groundbreaking book on slave religion, describes the essential elements of West African belief systems, particularly their unique religious concepts:

Common to many African societies was belief in a High God, or Supreme Creator of the world and everything in it … this High God was somewhat removed from and uninvolved in the activities of men, especially so when compared with the lesser gods and ancestor-spirits who were actively and constantly concerned with the daily life of the individual and the affairs of society as a whole … there were several fundamental beliefs concerning the relationship of the divine to the human; belief in a transcendent, benevolent God, creator and ultimate source of providence; belief in a number of immanent gods, to

whom people must sacrifice in order to make life propitious; belief in the power of spirits animating things in nature to affect the welfare of people; belief in priests and others who were expert in practical knowledge of the gods and spirits; belief in spirit possession, in which gods, through their devotees, spoke to men.[2]

This African idea of an all-powerful God who is ruler of the universe is reminiscent of most religions, including Christianity. However, Africans were considered to be heathens and pagans because they also believed there were deities who were God's intermediaries (both male and female). To invoke them, they participated in rituals and sacrifices, that were considered witchcraft by their European conquerors. In such rituals, the deepest felt religious experience is possession by God; surrounded by singing, drumming, and dancing, a person loses all touch with his conscious self. People suddenly "get happy," "shout," or "feel the spirit," behaving in a manner very different from secular behavior.

Many scholars have underscored the centrality of religion in African cultures and the extent to which it is an integral part of one's life, not something that is practiced once a week:

… in traditional society there are not irreligious people. To be human is to belong to the whole community, and to do so involves participating in the beliefs, ceremonies, rituals and festivals of that community. A person cannot detach himself from the religion of his group, to do so is to be severed from his roots, his foundation, his context of security, his kinships and the entire group of those who make him aware of his existence.… Therefore to be without religion amounts to a self-excommunication from the entire life of society, and African peoples do not know how to exist without religion.[3]

Africans maintain their connections to the spiritual world through their ancestors, whose spirits continue to roam the earth and who also act as intermediaries between gods and the living.

A major justification for slavery on the part of Europeans was the need to civilize African pagans, which included their conversion to Christianity. European invaders were blind to the fact that Christianity had already been brought to African peoples by earlier African converts, such as the apostle Philip (recorded in the Book of Acts 8:26–39), and by eleventh-, twelfth-, and thirteenth-century encounters with African monks and pilgrims. During the fourteenth century there were plans for "a joint crusade with the beloved black Christians of Nubia and the countries of Upper Egypt." Intense diplomatic and ecclesiastical contact between Christians from both continents continued well into the fifteenth century.[4] Europeans failed in their own understanding of the true God of Christianity – the eternal gentleman who never forces Himself on the

2 Albert J. Raboteau, *Slave Religion: The "Invisible Institution" in the Antebellum South* (New York: Oxford University Press, 1978), 8–12.

3 John S. Mbiti, *African Religions and Philosophy* (New York: Praeger, 1969), 1–5, 15.

4 Jan Nederveen Pieterse, *White on Black: Images of Africa and Blacks in Western Popular Culture* (New Haven: Yale University Press, 1992), 18–27.

unbelieving, but rather waits for the door to a soft heart to open willingly before entering in.

In the first century and a half of "the peculiar institution," as slavery was known in the United States, only a small number of Africans were actually taught about Christianity by their owners, though they regularly heard sermons urging obedience to white people and were taught to pray. Enslaved Africans were stripped from organized worship. They came to God not through the church but through faith, as God said He would reveal Himself to those who believe by faith (Romans 1:20). Generally speaking, southern plantation owners misused the Scriptures to justify slavery; the accompanying sentiment was that religious instruction would make slaves more rebellious and less willing to accept their servile status. It was in the aftermath of the religious revivals of the Great Awakening, which began in New England in the 1730s, that there was a more concerted effort to convert slaves to Christianity in the South.[5]

The message of salvation and the unconditional love of God conveyed by black (mostly Baptist) and white evangelical Protestant ministers were powerful draws for slaves. Other aspects of Christianity were just as compelling: slaves could identify with the sufferings of Jesus and His crucifixion and resurrection and with the biblical message of spiritual equality. The pictures of the children of Israel delivered by Moses – of Daniel in the lion's den, of David slaying Goliath – were forceful images that gave blacks hope of freedom from bondage.[6] By the late 1770s, blacks began to start their own separate churches and over time their adopted religion would become a source of comfort and release in the hostile and alien world of their captors.

Raboteau describes this long process, spanning nearly two hundred and fifty years, by which slaves came to accept Christianity, as a two-way street. "The slaves did not simply become Christians; they creatively fashioned a Christian tradition to fit their own peculiar experience of enslavement in America."[7] This development in many respects was not unlike the formation of early Christian churches among various gentile communities during the ministries of the apostles Paul, Peter, Timothy, and others. For many African American Christians, being forced to practice traditional Eurocentric forms of Christianity was and is akin to biblical Messianic Jews attempting to force circumcision on the Gentiles, for them to be considered true believers in Christ, a position for which the Jews were severely admonished by the apostle Peter (Acts 15:1–11). In the minds of many African Americans, a tradition of Christianity that does not allow space for cultural particularity and the voicing of the subaltern contradicts the very canons of the New Testament.

Over time, an evolving religious faith, which was a combination of traditional African spiritual elements and Christian devotional traditions, enabled displaced Africans to cope with the daily humiliations of racial

5 For additional information: Patricia U. Bonomi, *Under the Cope of Heaven: Religion, Society, and Politics in Colonial America,* Chapter 5: "The Hosannas of the Multitude: The Great Awakening in America" (New York: Oxford University Press, 1995); Frank Lambert, *Inventing the "Great Awakening"* (Princeton, N.J.: Princeton University Press, 2001); Juan Williams, *This Far by Faith: Stories from the African-American Religious Experience* (New York: William Morrow, 2003).

6 William S. Pollitzer, *The Gullah People and Their African Heritage* (Athens: University of Georgia Press, 1999), 137.

7 Raboteau, *Slave Religion,* 209.

oppression and perpetual suffering and to find comfort in the promise of a better future. By the eve of the Civil War and Emancipation, their own brand of Christianity – which included clandestine prayer meetings, ring shouts, and spirituals – had captured the heart, mind, and soul of the slave community. Put another way, hidden and beyond the control of the masters, the slave community had an all-embracing and vibrant religious life of its own.

During the Depression, between 1936 and 1938, the Works Progress Administration's Federal Writers' Project sent out-of-work writers in seventeen states to interview ordinary people and to then record their life stories. The stories of freed African American slaves were among those collected, including the account of a former slave who recalled singing and praying with other slaves huddled behind quilts and rags, which were hung in the form of a small room and wetted to keep the sound of their voices from penetrating the air. The fervor accompanying the practice of African religions was carried over to Christian worship and manifests itself still today. It is not uncommon to observe female as well as male members of spirit-filled churches (e.g. Baptist and Pentecostal churches) being "lifted in the spirit."

The world that slaves made for themselves helped to mitigate the isolation and debasement of bondage. Enslaved Africans did not simply accept slavery, they wanted to be able to interpret the culture of their new environment while accommodating their own culture in that oppressive environment. Africans and their descendants developed their own systems of social relations in the slave quarters as a part of a semiautonomous culture that borrowed from both African and European ways. Having accepted Christianity, and infusing it with overtones of African religious beliefs, enslaved Africans shaped a community uniquely their own. Their creativity extended to other aspects of community structure.

The practice of a distinctive culture that whites could not entirely control afforded blacks some small measure of power over their lives and encouraged slave solidarity. In addition, enslaved Africans were able to affect both their daily living conditions and their relationships with their masters. Slave children learned the rudiments of survival, a strong sense of morality, culture, and tradition from their elders through storytelling, games, and song. Songs and folktales were used to enlighten their minds, to educate, and to free souls. For example, the slave spirituals were a means to communicate feelings of discontent, exile, and hopelessness. However, not all songs were of despair and loss. They also sang songs expressing love, hope, and joy. Other than making use of lyrics as a form of expression, African slaves also used their stories and spirituals to outsmart their owners. This clever tactic involved the passing of vital information concerning meeting places, plans, or dangers through the actual hymns and stories which contained coded meanings in their words.[8]

8 Lawrence W. Levine, *Black Culture and Black Consciousness: Afro-American Folk Thought from Slavery to Freedom* (New York: Oxford University Press, 1977): 30–55.

Tapping into a deep spiritual reserve of powerful rituals and memories, African American slaves created artistic forms that carried past history from generation to generation. They distinguished themselves as builders, gold- and silversmiths, basket makers, furniture makers, and blacksmiths, as well as quilters. In fact, today there is no artistic form more closely associated with African American culture than quiltmaking.

Quilts represent skill, aesthetic beauty, and charm. However, for African American quilters the quilt became a covert manifestation of resistance within the context of storytelling. African American quilters found an outlet for their emotions, adversities, and experiences through quiltmaking. Under the most brutal conditions quilters forged a link to survival and an interpretive window on vernacular dimensions of the black experience in America with each tiny quilt stitch. Although slave quilters could not read or write, they left powerful "cultural documents" of the tragedy and humiliation that marked their lives. The quilter found self-worth and fulfillment with the completion of each colorful masterpiece. The "quilting," a slave term for what is more commonly known as a quilting bee, was a fun-filled, freewheeling affair organized by women, but also attended by men and children. Besides the necessary quilting, there was singing, dancing, storytelling, game playing, and eating. Quiltings served to unite the slave community and to give a brief respite from the misery of daily backbreaking work.[9]

Denied freedom but filled with artistic genius, quilters gave voice to the voiceless, transcended adversity, reclaimed history, and transformed the future of descendants of slaves through their work. As Van E. Hillard states:

As the Negro spiritual "I Shall Not Be Moved" reflects a tree planted by the water, the quilt shall not be moved as a tradition of defiance and dialectical response to social and political circumstances. The rhetoric of the quilt exposes systems of domination and illustrates the ways in which marginalized groups contest their experiences and express their meanings of the world. The quilt represents a ritualized practice of connection-making, unification and harmonizing.[10]

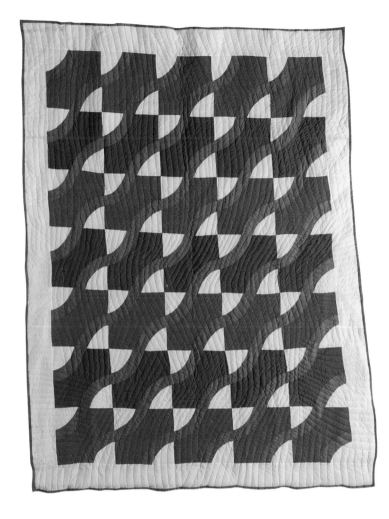

Fig. 1 *Lucy Marie Mingo,* Snake Quilt, *1995.*

9 Gladys-Marie Fry, *Stitched from the Soul: Slave Quilts from the Ante-Bellum South* (New York: Dutton Studio Books, 1990), 16–23.

10 Van E. Hillard, "Census, Consenus, and the Commodification of Form: The NAMES Project," *Quilt Culture: Tracing the Pattern,* ed. Cheryl B. Torsney and Judy Elsley (Columbia: University of Missouri Press, 1994), 116.

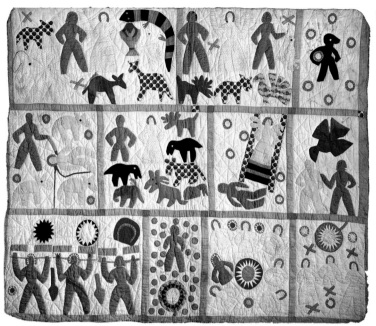

Fig. 2 *Harriett Powers,* Bible Quilt, *1886. 73 ¾ x 88 ½ inches. Cotton.*

■ Bearing Witness

Black women have always insisted upon being artists. They've insisted upon it since the first slaves incorporated African designs into the making of quilts.
Michele Wallace, 1989

African American quilting can reflect both African heritage and an embrace of Christianity. Africans brought with them a particular worldview, highly evolved artistic skills, and rich textile traditions, including the needlework techniques of appliqué, strip-piecing, patchwork, embroidery, and weaving. Patchwork is used in Egungun dance costumes of the Yoruba of Nigeria. The Hausa of Niger and Nigeria made pieced and quilted armor to protect horses and warriors during battle. Appliqué is the dominant textile needlework technique developed among the Fon of old Dahomey (now Benin), generated by people of high rank for ceremonial purposes. The Fon originally created their appliquéd banners and flags as a symbolic means of recording the deeds of battle and historic events in the lives of kings.[11]

Plantation rules forced slaves to quilt in a European tradition; however, they found ingenious ways to include African cosmology and mythology in quilts made for their white mistresses. There are documented slave-made quilts which feature the symbol of Erzulie, the Vodun goddess of love, cleverly disguised as flowers. Vodun is traceable to an African word for "spirit," and can be traced to the West African Yoruba people who lived in eighteenth- and nineteenth-century Dahomey. The snake motif, Damballah, the West African god of fertility, was also used.[12] The pattern is still popular today among elderly African American quilters living in Mississippi and Alabama (fig. 1).

Hundreds of quilts inscribed with Bible verses and religious pieties were produced in nineteenth- and twentieth-century America.[13] Making quilts with a narrative interpretation of Bible stories is relatively unusual in American quiltmaking; however, this type of quilt is idiosyncratic to African American women living in the South.[14] The most well-known and carefully researched Bible quilts were made by Harriet Powers, a former slave from Clarke County, Georgia. Her masterpieces reside in two of America's most prestigious museums – the National Museum of American History, Smithsonian Institution, Washington, D. C. (fig. 2), and the Museum of Fine Arts, Boston (fig. 3). Unable to read or write, Powers recorded local legend, biblical stories, and accounts of astronomical occurrences in her

11 John Gillow, *History of African Textile Works* (San Francisco: Chronicle Books, 2003).

12 Fry, *Stitched from the Soul,* 7, 63.

13 Eva Ungar Grudin, *Stitching Memories: African-American Story Quilts* (Williamstown, MA: Williams College Museum of Art, 1990), 16.

14 Cuesta Benberry, *Always There: The African-American Presence in American Quilts* (Louisville, KY: Kentucky Quilt Project, 1992), 43.

quilts, continuing an African oral
tradition in which stories taught
lessons, recorded historical events,
imparted religious beliefs, reinforced
values, instructed survival skills,
and entertained. Powers' machine-
stitched quilts are made in the
appliqué tradition of the Fon people
of Abomey, the ancient capital of
Dahomey, West Africa, the original
home of a large number of slaves
in Georgia. Appliqué was common
in the South between 1775 and
1875, and some scholars assert that
Africans introduced the appliqué
tradition to their white mistresses.[15]

Fig. 3 *Harriet Powers,* Pictorial Quilt,
*1895–98. 68⅞ x 105 inches. Pieced,
appliquéd, and printed cotton embroidered
with plain and metallic yarns.*

Powers exhibited her first
quilt at the 1886 Cotton Fair, where
it caught the attention of Jennie Smith, an academically trained artist and
administrator. Smith recognized the quilt as a masterpiece, and offered to
buy the work, but Powers refused to sell at any price. In 1890, Powers,
experiencing financial difficulties, sold her masterpiece to Smith for five
dollars. Powers was so distressed that she had to sell it, she would later visit
Smith several times just to see the work. Smith displayed the quilt at the
1895 Cotton States and International Exposition in Atlanta, where it was
admired by faculty wives of Atlanta University. The women commissioned
Powers to make a narrative quilt, her second, as a gift to the Reverend
Charles Cuthbert Hall, president of the Union Theological Seminary.[16]

Preserved with Powers' first quilt is an eighteen-page handwritten
narrative in which Smith describes the events that led to her purchase of
the quilt. Also included in the narrative is Powers' detailed interpretation
of each scene. The threat of God's judgment inextricably fused with His
mercy and man's redemption was a recurring theme in Powers' quilts. Her
first quilt deals with the stories of heroes from the Bible who successfully
overcome tremendous odds – Job, Noah, Moses, and Jonah. The stories of
the birth of Christ, the tempting of Eve in the Garden of Eden, the miracle
of Creation, John baptizing Christ, Judas at the Last Supper, and the cruci-
fixion of Christ are also depicted. In addition to biblical stories, Powers was
especially fascinated with astronomical phenomena. Legendary accounts of
actual events – eclipses, meteors, and comets – were mixed with traditional
motifs to create her second quilt. Her quilts are a lasting testament to her
artistic gifts, creative imagination, and deeply felt spiritual life.

Powers' earliest quilt measures 73¾ x 88½ inches, which is not bed
size. Because of its unusual size, there is speculation that the quilt may

15 Fry, *Stitched from the Soul,* 16–23.

16 Fry, *Stitched from the Soul,* 86.

have been used as a baptismal robe and that Powers was a priestess, a powerful woman in the community who invokes the spirits to heal the sick.[17] Quilting ceremonial garments is practiced to this day. Quilters have looked beyond the traditional forms of fiber art to make liturgical garments of exquisite beauty. An example on display in *Threads of Faith* is Cleota Proctor Wilbekin's *Communion Robe and Cross* (entry 41). Drawing strength from within her family, Wilbekin stitched memories and tradition into a chasuble for her minister. Composed of fabric remnants from four generations of female relatives, including pieces from her own wedding gown, the work honors the important station of the minister in the black community. The robe symbolizes the bonding of believers in Christ, recalling that they do not worship alone, but are connected to believers throughout time.

A reflection of their African heritage, the spiritual life of slaves extended beyond institutionalized religion and it did not conflict with their Christian beliefs. For just as the apostle Paul was empowered to heal through the gifts of the Holy Spirit, early African American Christians understood that these gifts were also available to them. Scholar Yvonne Chireau describes the alternative spiritual world of slaves as "secretive, mysterious, but quite real to those who have taken part in it," and that black folk traditions, such as "conjure," are a crucial site for an examination of African American spirituality, "where things of the unseen world become real and powerful, where human beings herald visitation of spirits."[18]

Conjure, "a tradition by which African American slaves and their descendants believed themselves able to manipulate spiritual forces and influence humans and events," is also called "rootwork or hoodoo,"[19] and it was one of the ways by which enslaved women in particular exercised spiritual authority in their communities. These women conjurers or healers (perhaps like Harriet Powers) believed that their special spiritual powers, which constituted a "calling," were gifts from God or the Holy Spirit as described in Romans 12:6–8 and 1 Corinthians 12:1–11. These "root-workers" would use charms, amulets, herbs, or other homemade objects to treat illnesses or ward off particular ailments. They were not above using practices comparable to those employed by Jesus when He healed the afflicted, whether with spittle (John 9:5–7), the hem of His garment (Matthew 14:35–36), or other unorthodox methodologies. The folk belief that certain black women in the community were seers, visionaries, fortunetellers, and healers with extraordinary supernatural insights would survive slavery.

The archetypal "spirit-woman" or healer remains a powerful icon within the African American folk tradition and is frequently invoked in black women's art, including textiles. Born in South Carolina in 1916, innovative contemporary quilter Elizabeth Talford Scott (the mother of well-known textile and bead artist Joyce Scott) embellishes her quilts with

17 Maude Southwell Wahlman, *Signs & Symbols: African Images in African American Quilts* (Atlanta: Tinwood, 2001), 73.

18 Yvonne Chireau, "Hidden Traditions: Black Religion, Magic, and Alternative Spiritual Beliefs in Womanist Perspective," *Journal of the Interdenominational Theological Center*, vol. 22, no. 2 (Spring 1995), 65, 69.

19 Ibid, 74–75.

buttons, found objects, and rocks, which are considered the dwelling places of spirits (including the ancestors) in African cosmology. This type of embellishing is thought to protect the wearer against all evil and harm.

Maude Wahlman asserts that Powers' "command of appliqué techniques, Fon symbols, Kongo symbols, Masonic symbols, and biblical scenes is powerful and extensive, and is clearly an illustration of both African and European influences in the religion and art of black women."[20] Wahlman also chronicles an African American Bible cloth tradition that precedes the two Powers quilts (1886 and 1895–98), and which may have been the result of the soul-stirring sermons of black preacher that were based on the Scriptures. Although slaves were prohibited from reading and writing, they were privy to the oral tradition in which biblical stories, committed to memory, were passed down from generation to generation. Wahlman identifies two patchwork Bible quilts from New Orleans that were probably made by a black woman as early as 1775; one consists of thirty-six appliquéd picture blocks with stories from the Old and New Testaments. According to Raboteau, "the biblical orientation of slave religion was one of its central characteristics. Stories, characters, and images from both Old and New Testaments pervaded the preaching, praying, and singing."[21]

So revered is Harriet Powers in the African American quilt community that she is affectionately known as "the mother of African American quilting." In 1997, Rhonda Mason, a member of the Women of Color Quilters Network, curated an exhibition entitled *Daughters of Harriet Powers: Tribute to an American Quilt Maker*. The exhibit featured quilts made by twenty-seven contemporary quilters from across the country, including ten by African Americans, who were inspired to create works to honor Powers' memory. Network member Peggie Hartwell, whose quilted tribute to Powers is included in this exhibition (entry 53), spent several years researching Powers' life in an attempt to locate her gravesite, so that the Network could place a memorial stone there. Although initial efforts to locate the specific site of her grave were unsuccessful, Hartwell was able to meet with Powers' great-great-great-grandniece, who advised that the grave was located somewhere in Athens, Georgia. So, the search continues.

In a style reminiscent of Powers' work, Yvonne Wells' *No Turning Back* (entry 29) engenders a walk of faith that bears witness to the joy of life with Christ. *No Turning Back* illustrates the deep religious faith and the power of spirituality in Wells' life. Enduring centuries of degradation, African American Christians learned to trust their faith, not their sight. This belief sustained black people's spiritual witness even when the facts contradicted the promises of God.

It is often said that one's faith cannot truly be measured until it is tested beyond that which we think can be measured. In Phyllis Stephens' *Bridge Over Troubled Waters* (entry 43), we are comforted by a call to cast all our cares upon the Lord and to trust that we will be delivered in the midst

20 Wahlman, *Signs & Symbols*, 64–65.

21 Raboteau, *Slave Religion*, 239.

of any tribulation. The quilt depicts a congregation of family and friends bearing witness to a baptism taking place in waters "troubled" (stirred up) by God. In the Bible these troubled waters were one of many ways miraculous healings occurred. It is an inviting scene, one that causes the viewer to take part in the celebration of the ceremony rather than to simply observe it as curious a onlooker.

Similarly, one cannot help being moved by the depth of faith conveyed in Gwendolyn Aqui's *Spirit Women* (entry 15). The work is a testament to the power of religious faith in helping women transcend life's trials and tribulations. A dazzling array of colors, Aqui's quilt embodies the "carnivalesque" qualities of a faith in Christ – a festival of faith, a celebration, and a dramatic rebirth. This abundance of joy is exemplified by the rich embellishments of beads, shells, metallic threads, and ribbons that Aqui uses to accent the piece. Works by such artists as Aqui, Stephens, and Wells bear witness to the range of creativity and styles deployed by contemporary African American quilters whose works are displayed in *Threads of Faith*.

■ Songs of Freedom

O Canaan, sweet Canaan,
I am bound for the land of Canaan.
FROM THE EPONYMOUS SPIRITUAL, 19TH CENTURY

The socio-political history of African Americans has been closely tied to religion, and the struggle for liberation has often been grounded in spirituality. From Emancipation to the mid-twentieth century, churches were the only institutions that African Americans felt were their very own. They were safe havens where African Americans could meet freely, support each other, organize, and exercise leadership. Sunday was the day for dressing up, shaking off the dust of the fields, and taking off the aprons that were their new badges of servitude. Over time, black churches became political spaces as well, places where African Americans could plan protests and envision a better life, free from the historic injustices that kept them second-class citizens.

The remarkable history of African American resistance has been continuous, from mutinies on slave ships, to slave insurrections throughout the colonies, to the dismantling of Jim and Jane Crow. Among African American women, resistance to oppression has been manifest in their art as well as in their activism. From slavery to the present, quilts have provided women with safe outlets for their social and political concerns, while serving as vehicles for their religious expression. Quilts have been both battle weapons and reflections of women's spiritual lives. When silenced by legal, political, and social norms, women of all ethnicities have voiced their sentiments through quilt making. Abolitionist quilts, suffrage quilts, temperance

quilts, and other liberation quilts are among the many artistic expressions that have recorded the passionate social and spiritual activism of quilters.

African American quilters glean inspiration from such political and social activist foremothers as Sojourner Truth, Maria M. Stewart, Frances Harper, Anna Julia Cooper, Julia Foote, Gertrude Bustill Mossell, Mary Church Terrell, and Ida B. Wells. The legacies of these women, many of whom were activists in such organizations as the Women's Christian Temperance Union, the American Woman Suffrage Association, and various denominational church groups, provide an important historiography for contemporary quilt makers' expressions of the African American cultural and spiritual experience. Likewise, the influential presence of African American forefathers, including Frederick Douglass, Nate Turner, Arthur Cooper, Booker T. Washington, W.E.B. Du Bois, and Marcus Garvey, conveys the importance of cultural history for many African American quilt artists, who utilize their craft to engage our social and spiritual consciousness as a vehicle to transform our society.

L'Merchie Frazier's *Jubilation: Is Freedom Visible* (entry 46) is a complex fabric montage that echoes the African American chronology of freedom's song. The design strategy of interlocking traditional quilt patterns with historical freedom-fighting images creates an "afro-circular" collage that challenges the viewer to interpret and understand diasporic African journeys to freedom. As the gifted writer Larry Neal suggests, such an artistic aesthetic links to the struggles of the people and embodies their voice and spirit.[22] Similarly, Diane Pryor-Holland's *Crossing Over* (entry 47) takes us on a visual journey from the abstract darkness of slave castle walls, drawing us into the calm of liberating color that is only possible through the healing force of forgiveness. The paradox of the imagery is a testament to those who survived the horrific past and is evidence of the fulfilled promise of healing. Gwen Magee's *Our New Day Begun* (entry 45) is a vibrant song of belonging and warmth drawn from the strength of the song known as the Negro National Anthem (see lyrics on page 147). The core of the quilt captures a sense of order and harmony that comes together from an outer searching. Its hypnotic properties allow for a level of relaxation that frees the mind to explore the distinctive patterns of an orchestrated fabric symphony. When viewed in the context of the artist's source of inspiration, the song "Lift Every Voice and Sing," the sense of a new awakening is imminent – for the artist and for African American people.

Quilting has been associated with protest throughout the course of American history. It is an extraordinary coincidence that two African American icons of liberation movements – emancipation in the nineteenth century and civil rights in the twentieth – were quiltmakers: Harriet Tubman and the "Mother of the Civil Rights Movement," Rosa Parks.

Born a slave in Maryland's Dorchester County around 1820, Harriet Tubman is perhaps the most well-known of all of the Underground

22 Larry Neal, "The Black Arts Movement," *Call and Response: The Riverside Anthology of the African American Literary Tradition,* ed. Patricia Liggins Hill (Boston: Houghton Mifflin Co., 1998) 1449–58.

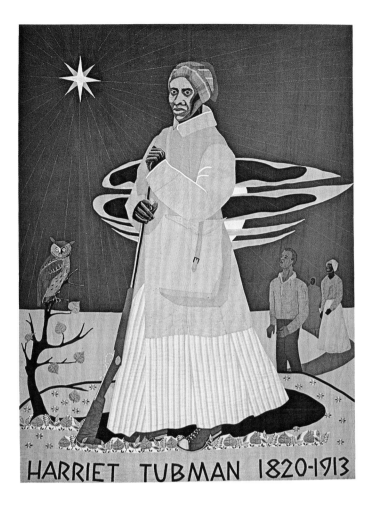

Fig. 4 Harriet Tubman Quilt, *designed by Ben Irvin and made by the Negro History Club of Marin City and Sausalito, California, 1951. 120 x 96 inches. Cotton appliqué.*

Railroad's "conductors" (fig. 4). During a ten-year span, Tubman made nineteen trips into the South, escorting over three hundred slaves to freedom. She proudly pointed out that in all of her journeys she "never lost a single passenger." In Tubman's memoirs she told the story of her most prized possession – a patchwork quilt she crafted as her wedding trousseau.[23] A self-taught quiltmaker, Tubman called the quilt the most beautiful thing she ever owned. She was helped in her first escape from Maryland by a white woman, to whom she give her cherished quilt as payment for her aid. Evidence of the importance of the quilt in Tubman's life is the fact she reminisced about its beauty to the end of her life. Sadly, no images of the quilt survive.

While the Civil War effectively ended slavery, and the passage of the Thirteenth (1865), Fourteenth (1868), and Fifteenth (1870) Amendments gave African Americans equal political rights, African Americans still faced considerable difficulties. For example, in 1865–66 Southern states passed black codes restricting the movement of blacks. The Ku Klux Klan and other terrorist groups used violence and lynching to keep the southern black population "in its place." Politicians passed laws, known as Jim Crow laws, that caused blacks to be separated from whites, and which prevented blacks from exercising their political rights; for example, many states made blacks take – and pass – literacy tests before they would be allowed to vote. In 1896, in the famous Plessy v. Ferguson case, the Supreme Court supported separate-but-equal laws.[24] This decision allowed the creation of separate schools and other public facilities, such as restrooms and drinking fountains, for whites and blacks.

Although the Civil Rights Movement gained tremendous popularity and support in the 1960s, its roots were in earlier times. From 1920 until about 1930, an unprecedented outburst of creative activity among African Americans occurred in all fields of the arts. Beginning as a series of literary discussions in the lower (Greenwich Village) and upper (Harlem) neighborhoods of Manhattan in New York City, this African American cultural movement would become known as the New Negro Movement, and later as the Harlem Renaissance. During this period a group of talented African Americans produced a sizable body of literature (in the four prominent genres of poetry, fiction, drama, and essay), as well as music (particularly jazz, spirituals, and blues), painting, and theater. More than a literary movement, and more than a social revolt against racism, the Harlem Renaissance exalted the unique culture of African

23 Ann Petry, *Harriet Tubman: Conductor on the Underground Railroad* (New York: Pocket Books, 1955).

24 Keith Weldon Medley, "The Sad Story of How 'Separate but Equal' Was Born," *Smithsonian Magazine*, February 1994, 106.

Americans and helped to redefine African American expression. African Americans were encouraged to celebrate their heritage and to become the "New Negro," a term coined in 1925 by sociologist and critic Alain Locke.[25] According to Locke, this New Negro had self-respect, independence, a new outlook, and he assumed roles of leadership. The New Negro would no longer subject himself to the humiliation heaped upon him by white America. Taking root in the African American community, these revolutionary ideas provided a catalyst for the Civil Rights Movement. One of the factors contributing to the rise of the Harlem Renaissance was the great migration of African Americans to northern cities (such as New York, Chicago, and Washington, DC) between 1919 and 1926. In his influential anthology of writings from the Harlem Renaissance, *The New Negro* (1925), Locke described the northward migration of blacks as "something like a spiritual emancipation."[26]

Despite cultural and economic changes ushered in by migration and urbanization, the status of African Americans remained largely unchanged. In the 1930s, most still lived in the southern United States, where they were racially segregated, politically disenfranchised, and economically marginalized. The fate of nine young black men (known as the Scottsboro Boys), who were accused of the gang rape of two white women on a freight train near Paint Rock, Alabama, on March 25, 1931, focused national and international attention on the fact that blacks in the South were completely beyond the protection of the law.[27] Many organizations were created after the Civil War to promote the goals of racial justice and equality, but progress was painfully slow. Not until the 1960s would efforts garner the necessary attention to force change. Groups like the National Association for the Advancement of Colored People, the Congress of Racial Equality, and Dr. Martin Luther King, Jr.'s Southern Christian Leadership Conference endorsed peaceful methods to spur progress, believing that change could be effected by working around the established system.

The contemporary Civil Rights Movement, generally believed to have begun with the Montgomery Bus Boycott of the late 1950s, was supported in black churches and in many instances was led by ministers. An inspirational mantra of the movement, "keep the faith," was a constant reminder of the bonds that connected the black church to the liberation struggles it helped to nurture. When victory seemed elusive, African Americans were sustained by a deep faith in their ability to overcome. African Americans kept their "eyes on the prize" and remembered the courage and faith of their ancestors.

In 1954, in the case Brown v. Board of Education, the Supreme Court ruled that segregation in public schools was unconstitutional. No longer would the doctrine of "separate" but "equal" be tolerated. Schools were ordered to desegregate with "all deliberate speed." This landmark

25 Alain Locke, *The New Negro* (New York: Simon and Schuster, 1999), 3.

26 Ibid., 19.

27 Gerald Horne, *Powell v. Alabama: The Scottsboro Boys and American Justice* (London: Franklin Watts, 1994).

Fig. 5 *Rosa Parks, the "Mother of the Civil Rights Movement," quilting at her home in Detroit, Michigan, 1986.*

decision strengthened the African American community's resolve to effect change and increased the momentum of the movement.

As early as May 1954, the Women's Political Council, founded in 1946 by Dr. Mary Fair Burks, wrote to Montgomery, Alabama, Mayor W. A. Gayle, informing him that African Americans were preparing to boycott the public transportation system due to previously unanswered requests to change seating and boarding practices.[28] Despite such precursory activities, many historians continue to date the beginning of the modern Civil Rights Movement in the United States to December 1, 1955, the day Rosa Parks, a highly respected but relatively unknown seamstress in Montgomery, refused to give up her bus seat to a white passenger. Although the earlier arrests of at least two black women for the same offense were known, Parks' arrest, given her standing in the community, caused outrage. The independent act of this brave and spiritually fortified woman resulted in her arrest and she was fined for violating a city ordinance, but her lonely act of defiance would prove to be a catalyst for the long and strategic collaboration to end segregation in America. It made Parks an inspiration to all who cared about freedom.

When once asked by someone if she knew how to quilt, Rosa Parks replied emphatically, "Any good woman my age from Alabama definitely knows how to quilt."[29] Parks' needle skills come as no surprise, considering that she's an Alabama native. Alabama is home to large groups of self-taught African American quilters, notably the quilters of Gee's Bend, whose works have been hailed as "some of the most miraculous works of modern art America has produced."[30]

Just five days after Rosa Parks refused to give her bus seat up to a white man, Dr. Martin Luther King, Jr. was elected president of the Montgomery Improvement Association, which was formed by blacks who had decided to boycott Montgomery's bus system. African American ministers played a significant role in the leadership continuum in the black experience from the days of slavery to the Civil Rights Movement. Noting their success in the bus boycott, King and two other ministers, Charles K. Steele and Fred L. Shuttlesworth, issued a call for clergymen who wanted to press for civil rights to meet in Atlanta. Sixty black ministers from ten states answered the call, and they formed the Southern Christian Leadership Conference (SCLC) in 1957 with Dr. King as president.[31] In the same year, King began to campaign for black voting rights. Black ministers utilized churches as instruments for social protest and resistance. The church was a point for mass gatherings to organize marches, rallies, and strikes.

After nearly a decade of nonviolent protests and marches, ranging from the 1955–56 Montgomery Bus Boycott to the student-led sit-ins of the 1960s, to the huge March on Washington in 1963, Congress finally passed the Civil Rights Act of 1964 and the Voting Rights Act of 1965,

28 Mary Banks, "Trailblazers: Women in the Montgomery Bus Boycott," *Women in the Civil Rights Movement: Trailblazers and Torchbearers, 1941–65*, eds. Vicki L. Crawford, Jacqueline Anne Rouse, and Barbara Woods (New York: Carlson Publishing, 1990), 71–83.

29 Roland L. Freeman, *A Communion of the Spirits: African-American Quilters, Preservers, and Their Stories* (Nashville: Rutledge Hill Press, 1996), 68.

30 Michael Kimmelman, *New York Times* art critic, in the *Times*, Nov. 29, 2002. For additional information, see John Beardsley, et al., *The Quilts of Gee's Bend* (Atlanta: Tinwood Books, 2002).

31 Taylor Branch, *America in the King Years,* vol. 2, *Pillar of Fire, 1963–65* (New York: Simon and Schuster, 1989), 260.

guaranteeing basic civil rights for all Americans, regardless of race. The modern African American Civil Rights Movement transformed American democracy by redefining citizenship for a disenfranchised people. It would serve as a model for other group advancement and group pride efforts involving women, students, gays, the elderly, and others.

The Montgomery Bus Boycott catapulted Dr. Martin Luther King, Jr. to fame and it was he who articulated the religious meaning of the Civil Rights Movement for America. Admiration for Dr. King and support of the movement inspired many African American quilters to make commemorative quilts. Out of

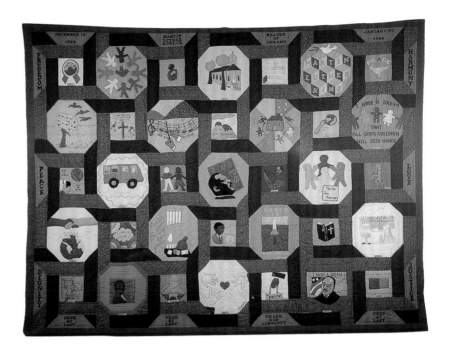

Fig. 6 *Marie Wilson,* Weavers of Dream, *1985.*

respect for him, quilters gave him quilts as he traveled throughout the South heralding his cause. The late Marie Wilson, a founding member of the Women of Color Quilters Network, designed the setting and coordinated the assembly of the *Weavers of Dream* quilt (fig. 6). Children in schools named for Dr. King across the nation submitted blocks for the quilt, each depicting a phase of King's life. Upon completion of the quilt, several African American quilters from New York City traveled to Atlanta to present this extraordinary gift to the King Center in Atlanta in 1980.

Commemorative quilts have been made in the United States since the founding of the nation. Quilts were made to celebrate special events, to confront moral or social issues, or to focus on the special interests of the quiltmaker. Many can be found in African American churches, where they might celebrate the pastor's anniversary, the building of a new church, the paying off of the church's mortgage, or perhaps stand in recognition of service to the church or holidays like Mother's Day. The last decade has witnessed commemorative quilts made on a grand scale, with hundreds, or even thousands of quiltmakers contributing to the finished work. Quilt projects such as those focusing attention on the AIDS crisis (AIDS Memorial Quilt), breast health awareness, and the September 11 tragedy are among the most prominent.

A direct result of the Civil Rights Movement was the establishment of what is now one the oldest cooperatives in the United States, the Alabama Freedom Quilting Bee, which was chartered in 1966. Father Walter Francis, an Episcopalian priest and civil rights activist, was driving through Dallas and Wilcox Counties in Alabama when he saw quilts hang-

ing on a clothesline. The colorful quilts had been made by Ora McDonald, who lived in Possum Bend, Alabama. Father Francis learned that the area had a number of women who could make quilts and he saw an opportunity for them to use their quiltmaking talents to earn a living. Many of the area residents had lost their homes and jobs as a result of registering to vote. They lived in one of the poorest and most isolated areas of the country. Father Francis took some of the quilts to New York City and was quickly able to sell them. In the early years of the Freedom Bee, the quilters' work was sold at both the Smithsonian Institution and at department stores, including Sears and Bloomingdales.

The Black Power movement of the late 1960s also influenced the African American quilting tradition and its transgressive features. Michael Cummings' quilt *Christ Bearing the Cross* (entry 9) asks us to move beyond white conceptions of Christ and is reminiscent of the messages of such black theologians as the Reverend Albert B. Cleage, Jr., who founded the Shrine of the Black Madonna Church in 1967 and who was a proponent of black nationalism. Cleage issued a call to all black churches to stop worshiping a white Jesus, and asserted with certainty that God must be black if He created black people in His own image. Cleage felt that African Americans could not build dignity by kneeling in supplication to a white Jesus.[32]

Others challenge the notion of a white Christ on the basis that Jesus was of ancient Semitic ancestry, for the Semite family includes Afro-Asiatic subfamilies, such as the Babylonians, the Assyrians, the Aramaeans, the Canaanites, and the Phoenicians. They convincingly contest fallacious racial categorization theories that were spawned during the Enlightenment. Pointing to the earliest European iconography of Africans, which dates to 2500 BC, and which depicts them as "well integrated into society and intermarrying," scholars across multiple disciplines have interrogated the theoretical flaws and the historical evidence of a white Jesus.[33] *Black Athena* (1987), the seminal work of historian Martin Bernal, is a compelling inquiry into the "Aryan" and "Ancient Greek" theories on which the iconography of the European-like Christ is based.[34] African American artists in both the visual and the literary arts frequently confront normalized Eurocentric representations in their work. Celebrated author and Nobel Prize-winner Toni Morrison captures the significance of these revelations in the following passage from her essay "Unspeakable Things Unspoken: The Afro-American Presence in American Literature":

It is difficult not to be persuaded by the weight of documentation Martin Bernal brings to his task and his rather dazzling analytical insights. What struck me in his analysis were the process of the fabrication of Ancient Greece and the motives for the fabrication. The latter (motive) involved the concept of purity, of progress. The former (process) required mis-reading, pre-determined

32 Williams, *This Far By Faith*, 236.

33 Nederveen Pieterse, *White on Black*, 23.

34 Martin Bernal, "Black Athena: Hostilities to Egypt in the Eighteenth Century," *The "Racial" Economy of Science: Toward a Democratic Future*, ed. Sandra Harding (Bloomington: Indiana University Press, 1993), 47–63.

selectivity of authentic sources, and – silence … [citing Bernal] "the essential force behind the rejection of the tradition of massive Phoenician influence on early Greece was the rise of racial – as opposed to religious – anti-semitism. This was because the Phoenicians were correctly perceived to have been culturally very close to the Jews." [35]

The breaking of this Eurocentric bondage has contributed to the freedom African American artists enjoy to create works that are rooted in a restored understanding of the "image and likeness of God." This awakening is not confined to the notion of reappropriating images of God and Jesus. Rather, it is a voicing of that which had been silenced. The quilts in *Threads of Faith* comprise a harmonious mass choir of this "restored voicing."

Perhaps one of the most emphatic examples of the restored voice can be found in Cummings' *Christ Bearing the Cross.* Beyond the physical signifiers of an African Messiah, Cummings' Christ suggests a story behind the image. The figure's gaze is set on an accuser, perhaps a sinner in the crowd for whom this Christ bears the cross. Different from the many traditional interpretations of Christ looking up to the heavens, or with eyes cast down in surrender, Cummings has positioned the focus of his Christ on those he has come to redeem. This exemplifies the power of an African American artistic aesthetic that connects with the struggles of the people.

Mutually shared tragedies are among the most poignant of life experiences through which artistic representation illustrates agency and social power transcending racial affinity. Though the quilts in *Threads of Faith* are products of the unique experiences of the African American community, often the artists' works speak for the country in ways that transcend race. The Civil Rights era provided fertile soil for artistic expressions that captured a legacy of benefits for diverse peoples as the spoils of those turbulent times. Not the least of these spoils was the voicing of a variety of social movements, including the feminist movement, farm worker organizations, environmental movements, anti-war groups, and the gay rights movement. Likewise, many of the quilts in this American Bible Society exhibition gracefully and poetically cross over the lines that too easily divide us. When studied to glean a deeper understanding of the human condition, quilts about the black experience are never just for or about black people. A timeless example is evident in the work of Alice Beasley.

In 1996 Beasley's quilt *Behind the Barricade* (entry 50) was one of twenty selected to travel throughout the United States to commemorate the children who died in the bombing of the Alfred P. Murrah Federal Building in Oklahoma City the year before. In the aftermath of the September 11 tragedies, Beasley's quilt is a resounding echo of our shared grieving and consequently of our shared journey of hope and healing.

35 Toni Morrison, "Unspeakable Things Unspoken: The Afro-American Presence in American Literature," *Michigan Quarterly Review*, vol. XXVII, no. 1 (Winter 1989), 7–8.

Beasley meticulously applies swatches of patterned fabrics, piece by piece, to chilling effect. Her portraiture skills bring to life the gripping fear, confusion, and questioning disbelief of her subjects. Through her mastery we come face to face with believing the unbelievable. We are in Oklahoma, we are with the children, we experience their loss, and we are frozen without words. Yet it is the children who are voiced in Beasley's powerful expression.

While Cynthia H. Catlin's *Peace at Christ's Birth* (entry 7) and Theresa Polley-Shellcroft's *The Annunciation: Be It Unto Me According to Thy Word* (entry 8) draw on hope through the Christ child, these quilts also send messages of healing and family values. Catlin's quilt is a vibrant Christmas reminder that "God loved the world so much, that he gave his only Son, so that everyone who believes in him may not die but have eternal life." (John 3:16) Polley-Shellcroft's *Annunciation* conveys the Christian family value of humility in the midst of greatness. The young Mary, blessed beyond her comprehension, humbly agrees to be the chosen vessel to fulfill God's plan of redemption. As the angel pours out an anointing of the Holy Spirit, explaining the wonders of God, Mary's willing reply is simply, "may it happen to me as you have said." (Luke 1:38) The quilt's calming blue and pink color pallet engenders Mary's humble countenance, leaving the viewer with a sense of peace in the midst of the challenging path Mary's life is about to take. This message of calm in God's presence in the midst of trial is one that resonates throughout the history of the African American experience.

■ Journeys of Hope

Black women are a prism through which the searing rays of race, class and sex are first focused, then refracted. The creative among us transform these rays into a spectrum of brilliant colors, a rainbow which illuminates the experience.
Margaret B. Wilkerson, 1986

In her compelling and moving essay "In Search of Our Mothers' Gardens," Alice Walker asks us to imagine the unimaginable:

What did it mean for a black woman to be an artist in our grandmothers' time? In our great-grandmothers' day? … was she required to bake biscuits … when she cried out in her soul to paint watercolors of sunsets … or was her body broken and forced to bear children … when her one joy was the thought of modeling heroic figures of rebellion, in stone or clay?[36]

Walker then asks an even more haunting question: "How was the creativity of the black woman kept alive, year after year and century after century?"

36 Walker, *In Search of Our Mothers' Gardens*, 231–43.

Earlier she offers her own explanation: "They were creators … because they were so rich in spirituality – which is the basis of Art."[37] Many African American writers have attempted to articulate the source of black womens' resilience and what Walker calls the "creative spark" that was passed down from generation to generation:

The spiritual world of my growing up was … very akin to those described in novels by Toni Morrison, Paule Marshall, or Ntozake Shange. There was in our daily life an ever present and deep engagement with the mystical dimensions of Christian faith. There was the secret love of the ancestors – the Africans and native Americans – who had given that new race of black folk … whole philosophies about how to be One with the universe and sustain life. That love was shared by the oldest of the old, the secret believers, the ones who had kept the faith … there was … a profound unspoken belief in the spiritual power of black people to transform our world and live with integrity and oneness despite oppressive social realities … black folks collectively believed in "higher powers," knew that forces stronger than the will and intellect of humankind shaped and determined our existence, the way we lived.[38]

In a culture that devalues black women, often defining them as ugly, hypersexual, or profane, it has been important for women artists to affirm the joys of black womanhood, to celebrate their strength, worthiness, and beauty. It is noteworthy that black women, perhaps more than any other group in the United States, have had to rely on themselves for a positive sense of self. Black family life has also been devalued, a legacy of slavery, so that it has been imperative for African Americans to honor ancestors, to affirm the sacredness of marriage, and to celebrate the sanctity of the home. In this regard, African American women have had to constantly proclaim their enduring family values and strong kinship ties to a cynical dominant culture.

Yvonne Wells' *Woman I Am* (entry 14) captures the complexity of black womanhood, while underscoring the importance of moving beyond stereotypical, uni-dimensional portrayals of African American women. Here there are many images, including the familiar domestic servant and the religious woman, who wears a cross over her heart indicating her faith in the Lord. Diane Pryor-Holland's *Her Coat of Arms* (entry 21) and Dindga McCannon's *Sisters in the Spirit* (entry 23) both honor the sisterhood bonds that bind black women to each other despite the difficulties they continue to face in a hostile world. Marla Jackson's *First Born* (entry 20) affirms the sanctity of marriage and family within black communities, at a time when the demographic data would suggest otherwise. Michele David's *Church Ladies* (entry 18) depicts familiar images in black communities, linking us to the past while reminding us of the world of our grandmothers, as well as of the countless "dressed-to-kill" urban

37 Walker, *In Search of Our Mothers' Gardens*, 233.

38 Bell Hooks, *Sisters of the Yam: Black Women and Self-Recovery* (Boston: South End Press, 1993).

women who have remained anchored to their faith. Sherry Whetstone-McCall's *Mother Dear, Our Matriarch* (entry 17) is a tribute to her maternal ancestors, whose strength, courage, and intelligence have enabled her and the rest of the family to endure.

The history of the African American family is a story of the struggle to rebuild stable family institutions that would fill the emotional, cultural, and spiritual voids created when African people were first brought over as slaves. Despite the restrictive legalities of slavery, black men and women continued to form unions, joining together in marriage ceremonies, which varied from jumping over a broomstick together to exchanging vows in front of a white minister. Although many of these couples lived apart from one another, spouses often traveled great distances at night to visit their loved ones. This "night-walking," a family institution born of necessity, employed a network of foot trails that became physical landmarks of the family ties that kept the African American community connected.[39] Barbara G. Pietila's *Color Him Father* (entry 19) is an unusual testament to black fathers and the bond between them and their daughters. At a time when black men are portrayed in the popular media primarily as criminals, hustlers, gang-bangers, and deadbeat fathers, this quilt is a refreshing reminder of the reality of the supportive men who have played an important role in black families since slavery.

Denise M. Campbell's provocative piece *Would the Real Jemima Please Stand Up and Claim Her Inheritance?* (entry 48) is a compelling exhortation intended to incite and encourage the viewer to seek scriptural truth about the Lord's plan for a godly image and likeness of the African American woman. In Campbell's words, she boldly marched into the enemy's camp (the pancake box imagery that was appropriated as a caricatured symbol of degrading servitude – a source of resentment and humiliation for many in the African American community) and took back what the devil stole. God's true image of Jemima is described in the Bible:

The LORD blessed the last part of Job's life even more than he had blessed the first. Job owned fourteen thousand sheep, six thousand camels, two thousand head of cattle, and one thousand donkeys. He was the father of seven sons and three daughters. He called the oldest daughter Jemimah, the second Keziah, and the youngest Keren Happuch. There were no other women in the whole world as beautiful as Job's daughters. Their father gave them a share of the inheritance along with their brothers. JOB 42:12–15

That the name Jemima has become a racially charged word is illustrated in the 2003 film *Bringing Down the House,* starring Queen Latifah. In it, "Jemima" is hurled in a racially motivated prelude to an all-out bathroom brawl between a white and a black woman, a painful reminder that the sting of Jemima as an insult is alive and well even today. Campbell anchors

39 Herbert G. Gutman, *The Black Family in Slavery and Freedom, 1750–1925* (New York: Pantheon Books, 1976).

her piece in the Jemima of Job, infinitely blessed and flowing from a Christ-like position of servant leadership to those in need, not from a position of forced servitude to the privileged elite. Drawing on the hopes of our social and spiritual activist foremothers, she suggests that we cannot discuss racial reconciliation without discussing racial restoration. Reclaiming God's truth about Jemima is part of Campbell's journey of hope for the racial harmony God intended, as He repeatedly urges throughout His word.

For African Americans, the process of quiltmaking is itself a spiritual journey, where the Holy Spirit pours out an anointing over both the quilter and the quilt. It is not uncommon for the Christian quilter to pray over and into the quilt, just as handkerchiefs and aprons touched by the apostle Paul were anointed to miraculously heal the sick. (Acts 19:11–12) It is a sacred and consecrated experience. The journey of the African American quilter is indeed a journey of hope. It is a calling. It is a ministry.

This collective ministry has never before been so clearly manifested as it is in the quilts that comprise the *Threads of Faith* exhibition. Phyllis Stephens' *A Place for You* (entry 10) and Ed Johnetta Miller's *Healing Spirit II* (entry 34) are comforting salves that assuage the loss of beloved family members, reflecting the hope that we have in God's promises.

Stephens displays her compositional mastery in the heavenly mansion containing many mansions, each uniquely crafted to match the personalized specifications God has designed for each of us. She captures a sense of continuity and unity, while sustaining the diversity that God so wonderfully created in each of his children, as reflected in the eternal homes he has prepared for them. Each human being is a celebration of God's abundant love of diversity and each mansion is correspondingly different. Knowing that God has prepared such a special dwelling place for each of his loved ones is a comforting reassurance when he calls our loved ones home to him.

Miller's *Healing Spirit II* is a commanding performance in the abstract. The forceful palette and sharp angularity of the quilt create an intense moment of tenacity, drawing the eye to striking focal points around and between intersecting elements. Miller's quilt is a revealing tribute to these same qualities in her spiritually fortified father. Its underlying message is clear – hold fast to the anchor of God in the midst of your storm, a message repeated in many quilts and one that has sustained African Americans through centuries of turbulent times.

A call to praise and worship the God of creation, with all His wonder and perfect timing through life's journeys, is the lesson imparted by Myrah Brown Green's *And a Time to Dance* (entry 13), Trish Williams' *Dance of Praise* (entry 38), Theresa Polley-Shellcroft's *Lift Up Thine Eyes*

Unto Heaven (entry 26), Cynthia Lockhart's *Make a Joyful Noise Unto the Lord* (entry 39), and Cathleen Richardson Bailey's *Stirred Up* (entry 12). Williams introduces the viewer to an outpouring of the Holy Spirit, where women engage in uninhibited praise of God. The Bible tells us that God is pleased with the praises of his people. Even King David, a man after God's own heart, danced himself into a frenzied spectacle in celebration of the mercy God bestowed on him. Although David's wife Michal rebuked him for such a display (2 Samuel 6:20–23), David knew that God was pleased with the abandon of his love. Such unabashed praise and worship are today a hallmark of many "spirit-filled" churches. Utilizing a very different genre, Polley-Shellcroft takes us to a place of meditation. To gaze upon this subtle portrait of praise is to enter into a space where one can ponder the awesomeness of God. Polley-Shellcroft's color selection, fabric placement, and intriguing embellishments direct the eye in a dance of wonder.

Kyra E. Hicks' *The Lord's Prayer Quilt* (entry 31), Zene Peer's *Prayer Closet* (entry 33), and Cynthia H. Catlin's *Pray in the Spirit Quilt* (entry 35) are inspiring testimonies reflecting the power of prayer. *Prayer Closet* conveys an uplifting message of strength through prayer. Peer's interesting application of paint, paper, and embroidery packages the message in a unique artistic style that draws the viewer into a study of the piece. On the other hand, Catlin's quilt is as delightful a study in quilting technique as it is in the power of prayer. The quilted border becomes the turned pages of the artist's favorite biblical passages, giving the viewer an added layer of insight into her inspiration.

A convincing reminder that there are angels in our midst – angels who serve and guide us, while we continually entertain their company unaware – is the work done by Marla Jackson's moving piece *Angelic Watch* (entry 49). Cleverly disguised in the attire of a devoted grandmother, this angel is the model of the Proverbs 31 woman, and undoubtedly she is also a masterful quilter, judging by her basket of exquisite fabrics and quilting supplies.

There are few greater or more ideal opportunities for the understanding of a society than through an engaged cultural experience that embodies the spiritual and artistic expressions of its people. As the quilts in this exhibition reveal, African notions of spirituality and Christianity, including black religious radicalism, have been critically important to the survival of African Americans. Experiencing the fifty-three quilts in *Threads of Faith,* by thirty-three of the most insightful and talented members of the African American quilting community today, offers a truly unique occasion for cultural understanding and enrichment.

Carolyn Mazloomi,
West Chester, Ohio

Sacred Moments: From Scripture to Cloth

Adriene Cruz

I researched the Bible for an affirmation to address the struggle of wise action. I hoped to match the beauty of the words with the surrounding design, creating a prayer cloth of inspiration.

PROVERBS 7.4 *Treat wisdom as your sister, and insight as your closest friend.*

EDUCATION
1975 BFA, School of Visual Arts, New York, NY
1991 Oregon School of Arts and Crafts, Portland, OR

POSITION
Artist

SELECTED COLLECTIONS
Schomburg Center for Research in Black Culture, New York, NY

Hartsfield International Airport, Atlanta, GA

Harborview Medical Center, Seattle, WA

Portland Community College, Portland, OR

SELECTED AWARDS
Cultural Heritage Honor, Seattle, WA

Visual Arts Fellowship, Interstate Firehouse Cultural Center, Portland, OR

Individual Artist Fellowship, Oregon Arts Commission, Salem, OR

Lilla Jewel Award for Women Artists, McKenzie River Gathering Foundation, Portland, OR

Bonnie Bronson Fellowship, Portland, OR

SELECTED EXHIBITIONS
1999 *Spirits of the Cloth: Contemporary Quilts by African American Artists*, American Craft Museum, New York, NY

SELECTED REFERENCES
Freeman, Roland L., *A Communion of the Spirits: African-American Quilters, Preservers, and Their Stories*, Nashville, TN: Rutledge Hill Press, 1996: 356–57.

Mazloomi, Carolyn, *Spirits of the Cloth: Contemporary African-American Quilts*, New York: Clarkson Potter/Publishers, 1998: 70–71, 74, 120–21, 152–53, 177.

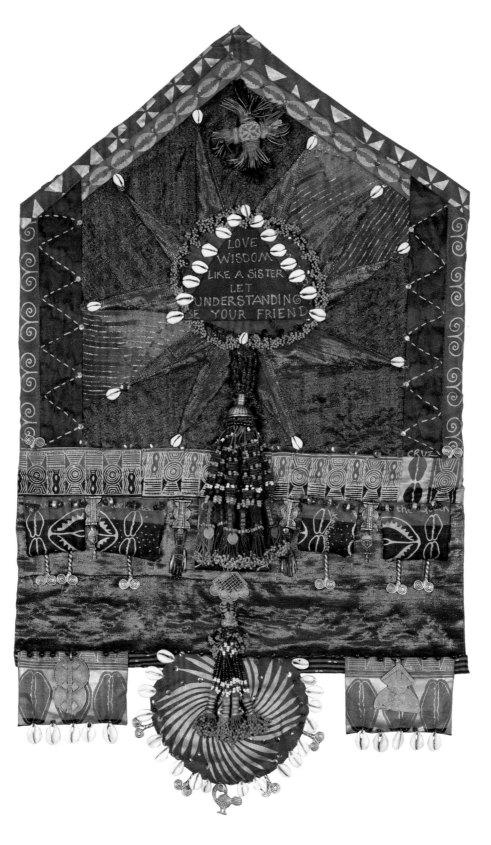

Within the artwork:

LOVE
WISDOM
LIKE A SISTER
LET
UNDERSTANDING
BE YOUR FRIEND

1 **PROVERBS 7.4** *2003. 30 x 18 inches. Cotton and metallic fabrics, brass and beaded ornaments, cowrie shells, lemon verbena.*

Adriene Cruz

Deborah is the most challenging work I've ever created. The project required research in unfamiliar territory, the Bible. I read the short passage about Deborah over and over again unable to "see" her. Finally I used an old photograph of my Jamaican great-grandmother, Mabel Gurtin, as my guide. I trusted her spirit would be with me to paint the face of a wise woman with divine power. Feeling that the palm tree must be blessed with wisdom and power, I painted faces on the front of the tree's fronds. The eyes of the faces represent visions of the ancestors.

JUDGES 4.4–9 *Now Deborah, the wife of Lappidoth, was a prophet, and she was serving as a judge for the Israelites at that time. She would sit under a certain palm tree between Ramah and Bethel in the hill country of Ephraim, and the people of Israel would go there for her decisions. One day she sent for Barak ... and said to him, "The LORD, the God of Israel, has given you this command: 'Take ten thousand men from the tribes of Naphtali and Zebulun and lead them to Mount Tabor. I will bring Sisera, the commander of Jabin's army, to fight you at the Kishon River. He will have his chariots and soldiers, but I will give you victory over him.'"*

Then Barak replied, "I will go if you go with me, but if you don't go with me, I won't go either."

She answered, "All right, I will go with you, but you won't get any credit for the victory, because the LORD will hand Sisera over to a woman." So Deborah set off for Kedesh with Barak.

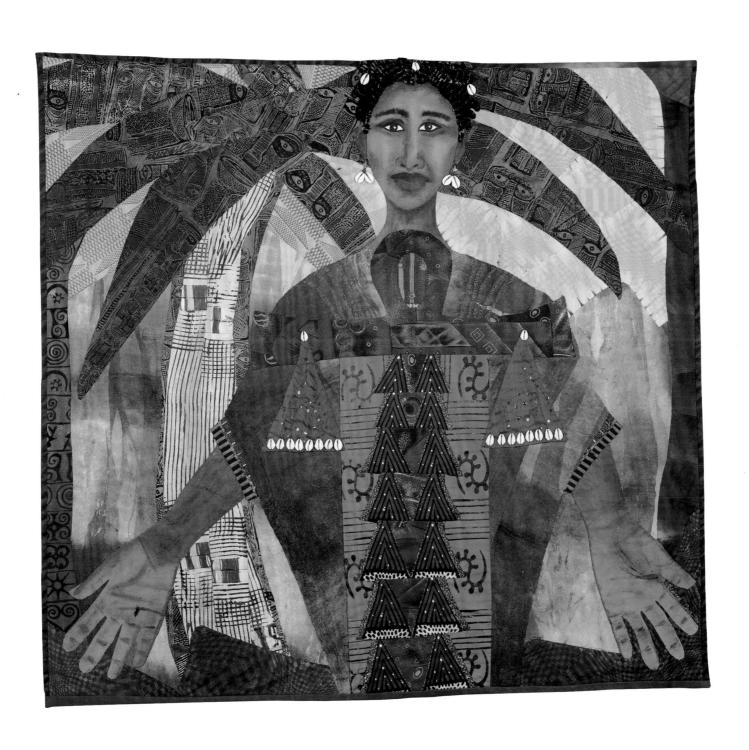

2 PALM TREE OF DEBORAH *1995. 36 x 38 inches.*
Cotton, acrylic paint, beads, shells.

Peggie Hartwell

Eve, ancestral matriarch ... decisions and consequences are held in her arms. "We may eat the fruit of any tree in the garden, except the tree in the middle of it."

GENESIS 3.1–11 *Now the snake was the most cunning animal that the LORD God had made. The snake asked the woman, "Did God really tell you not to eat fruit from any tree in the garden?"*

"We may eat the fruit of any tree in the garden," the woman answered, "except the tree in the middle of it. God told us not to eat the fruit of that tree or even touch it; if we do, we will die."

The snake replied, "That's not true; you will not die. God said that because he knows that when you eat it, you will be like God and know what is good and what is bad."

The woman saw how beautiful the tree was and how good its fruit would be to eat, and she thought how wonderful it would be to become wise. So she took some of the fruit and ate it. Then she gave some to her husband, and he also ate it. As soon as they had eaten it, they were given understanding and realized that they were naked ...

That evening they heard the LORD God walking in the garden, and they hid from him among the trees. But the LORD God called out to the man, "Where are you?"

He answered, "I heard you in the garden; I was afraid and hid from you, because I was naked."

"Who told you that you were naked?" God asked. "Did you eat the fruit that I told you not to eat?"

EDUCATION
1978 BA, Theater, Queens College, New York, NY
1992 Lifetime Career Schools, Certificate of Doll Making and Repair, Archbald, PA
1998–99 Fashion Institute of Technology, New York, NY

SELECTED COLLECTIONS
Miami Children's Museum, Miami, FL
Middlebury College Museum of Art, Middlebury, VT
American Craft Museum, New York, NY
National Afro-American Museum and Cultural Center, Wilberforce, OH
Children's Museum, New York, NY

SELECTED AWARDS
1999 Lower Manhattan Cultural Center Grant Recipient
1996 National Quilting Association Grant Recipient
1995 Empire State Craft Alliance Grant Recipient

SELECTED EXHIBITIONS
2003 Auburn University, Auburn, AL
2002 National Civil Rights Museum, Memphis, TN
2001 Museum of Afro American History, Boston, MA
1999 *Spirits of the Cloth: Contemporary Quilts by African American Artists*, American Craft Museum, New York, NY
1998 *In the Spirit of the Cloth*, Museum of Fine Art, Spelman College, Atlanta, GA
1996 *Spirit of the Cloth: African-American Story Quilts*, Wadsworth Atheneum, Hartford, CT

SELECTED REFERENCES
Freeman, Roland L., *A Communion of the Spirits: African American Quilters, Preservers, and Their Stories*, Nashville, TN: Rutledge Hill Press, 1996: 59, 166-69, 317.

Hicks, Kyra E., *Black Threads: An African American Quilting Sourcebook*, Jefferson, NC: McFarland & Co., 2003.

Mazloomi, Carolyn, *Spirits of the Cloth: Contemporary African-American Quilts*, New York: Clarkson Potter/Publishers, 1998: 60, 86–87, 134, 182.

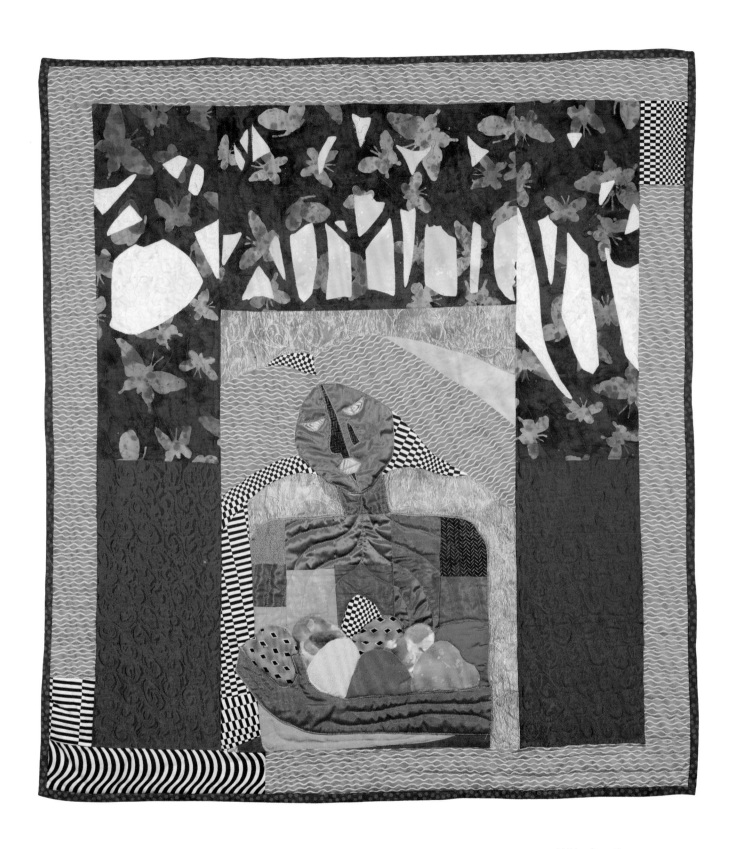

3 **EVE'S GARDEN** *2001. 42 x 38½ inches. Cotton, rayon, silk, cotton and metallic threads; machine embroidered, machine quilted.*

Peggie Hartwell

Dedicated to mothers who struggle to make our world a safer and more peaceful place for children. It is through their ageless and selfless love that humanity continues to evolve into a patchwork of endurance and hope. Dedicated to these strong daughters of the earth who through timeless efforts present us with the fruits of their struggles from one generation to the next.

GENESIS 21.14–20 *Early the next morning Abraham gave Hagar some food and a leather bag full of water. He put the child on her back and sent her away. She left and wandered about in the wilderness of Beersheba. When the water was all gone, she left the child under a bush and sat down about a hundred yards away. She said to herself, "I can't bear to see my child die." While she was sitting there, she began to cry.*

God heard the boy crying, and from heaven the angel of God spoke to Hagar, "What are you troubled about, Hagar? Don't be afraid. God has heard the boy crying. Get up, go and pick him up, and comfort him. I will make a great nation out of his descendants." Then God opened her eyes, and she saw a well. She went and filled the leather bag with water and gave some to the boy. God was with the boy as he grew up; he lived in the wilderness of Paran and became a skillful hunter.

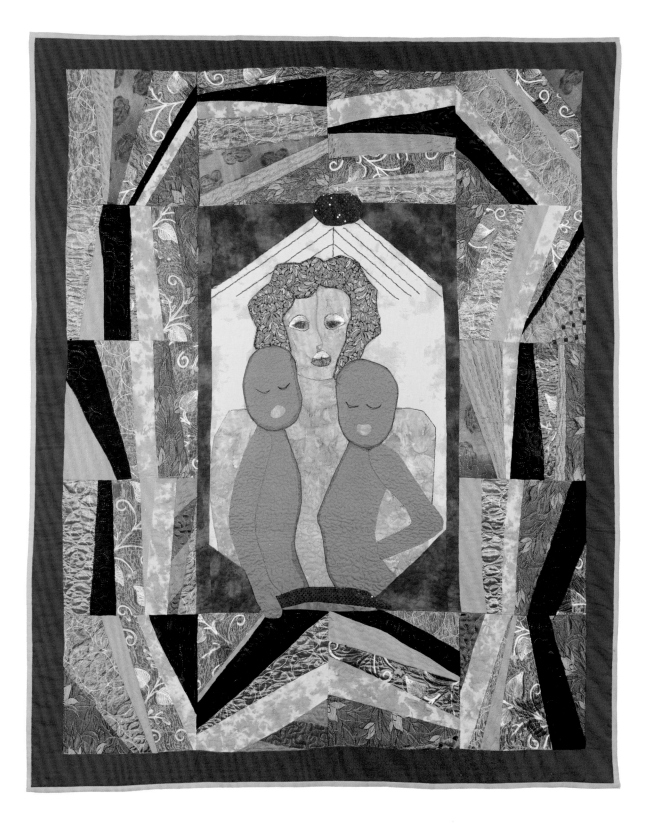

4 HAGAR AND HER CHILDREN *2000.*
64 x 51 inches. Silk, rayon, velvet, brocade, cotton and metallic threads; machine appliqué, machine quilted, hand embroidered.

Michele David

This quilt is inspired by the story of Moses crossing the desert and seeing a burning bush and God spoke to him.

EXODUS 3.1–6 *One day while Moses was taking care of the sheep and goats of his father-in-law Jethro, the priest of Midian, he led the flock across the desert and came to Sinai, the holy mountain. There the angel of the LORD appeared to him as a flame coming from the middle of a bush. Moses saw that the bush was on fire but that is was not burning up. "This is strange," he thought. "Why isn't the bush burning up? I will go closer and see."*

When the LORD saw that Moses was coming closer, he called to him from the middle of the bush and said, "Moses! Moses!"

He answered, "Yes, here I am."

God said, "Do not come any closer. Take off your sandals, because you are standing on holy ground." I am the God of your ancestors, the God of Abraham, Isaac and Jacob." So Moses covered his face, because he was afraid to look at God.

EDUCATION
1988 MD, University of Chicago, Chicago, IL
1996 MPH, Harvard University, Cambridge, MA

POSITION
Assistant Professor of Medicine, Boston University Medical School, Boston, MA

Co-Director, Haitian Health Institute at Boston Medical Center, Boston, MA

SELECTED AWARDS
2000 Outstanding Physician Award, Harvard Pilgrim Health

SELECTED EXHIBITIONS
2003 *NY Quilts!*, Russell Sage College, Troy, NY
 First Parish, Brookline, MA
2002 Massachusetts Medical Society Annual Art Exhibit, Nashua, NH
2000 Boston University Art Exhibit, Boston, MA

SELECTED REFERENCES
"Creations. Metamorphosis," *Unitarian Universalist World Magazine*, vol. XVII, 2003, No. 3: 15.

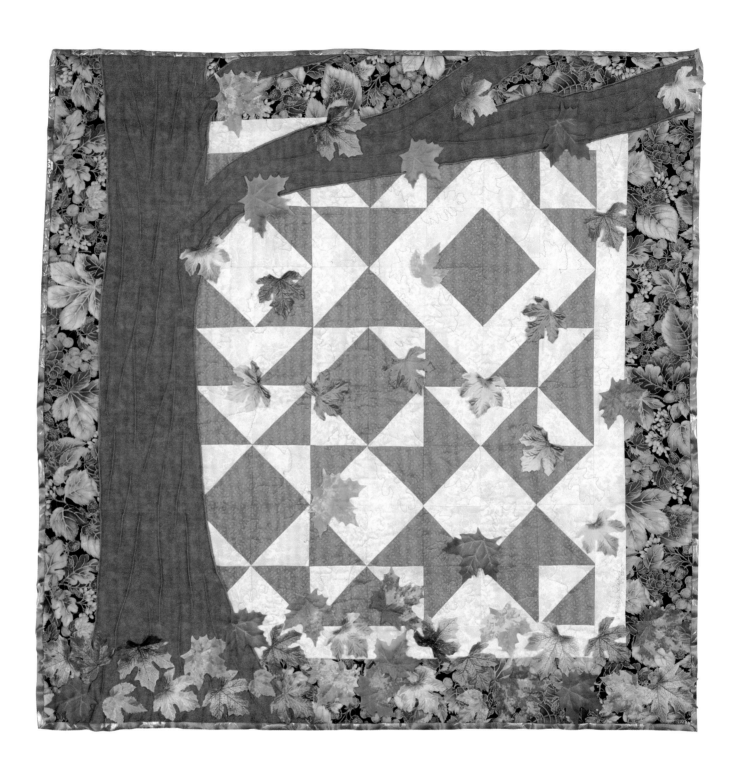

5 **THE BURNING BUSH** *2003. 40½ x 40 inches. Cotton;*
machine appliqué and quilted.

Michele David

Genesis inspired this quilt: and God created the earth. He created plants and animals and put them on the earth to grow.

GENESIS 1.1–3, 6, 9, 11, 20–21, 24–25 *In the beginning, when God created the universe, the earth was formless and desolate. The raging ocean that covered everything was engulfed in total darkness, and the Spirit of God was moving over the water. Then God commanded, "Let there be light" – and light appeared.*

Then God commanded, "Let there be a dome to divide the water and to keep it in two separate places" – and it was done.

Then God commanded, "Let the water below the sky come together in one place, so that the land will appear" – and it was done.

Then he commanded, "Let the earth produce all kinds of plants, those that bear grain and those that bear fruit" – and it was done.

Then God commanded, "Let the water be filled with many kinds of living beings, and let the air be filled with birds." So God created the great sea monsters, all kinds of creatures that live in the water, and all kinds of birds. And God was pleased with what he saw.

Then God commanded, "Let the earth produce all kinds of animal life: domestic and wild, large and small" – and it was done. So God made them all, and he was pleased with what he saw.

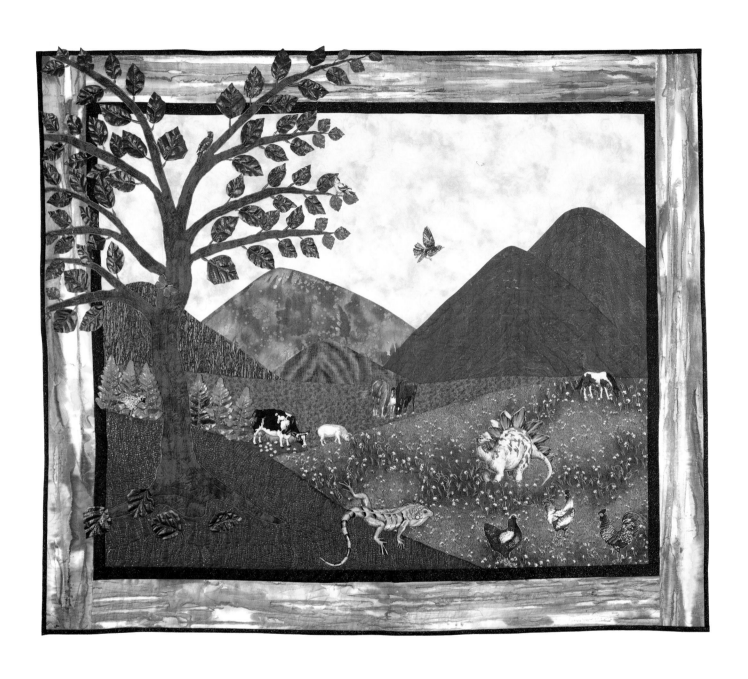

6 **THE CREATION: AND GOD CREATED THE EARTH** *2003. 55 x 47 inches. Commercial cotton fabrics, silk leaves, tulle, cotton and metallic threads; appliqué and machine quilted.*

Cynthia H. Catlin

This fiber art wall hanging was created to honor and pay tribute to the real significance of Christmas. Often the countless materialistic effects surrounding the celebration of Christmas distract us. In addition, we are robbed of the peace and joy of Christ's birth. The celebration of Christmas ought to focus on the true biblical origin as stated in Matthew 2.1–2: "After Jesus was born in Bethlehem in Judea, during the time of King Herod, Magi from the east came to Jerusalem and asked 'where is the one who has been born king of the Jews? We saw his star in the east and have come to worship him.'" For me the peace of this event recalls Psalm 122.8: "For the sake of my brothers and friends, I will say, Peace be with you."

LUKE 2.8–14 *There were some shepherds in that part of the country who were spending the night in the fields, taking care of their flocks. An angel of the Lord appeared to them, and the glory of the Lord shone over them. They were terribly afraid, but the angel said to them, "Don't be afraid! I am here with good news for you, which will bring great joy to all the people. This very day in David's town your Savior was born – Christ the Lord! And this is what will prove it to you: you will find a baby wrapped in cloths and lying in a manger."*

Suddenly a great army of heaven's angels appeared with the angel, singing praises to God: "Glory to God in the highest heaven, and peace on earth to those with whom he is pleased!"

EDUCATION
1979 BA, University of Toledo, Toledo, OH

POSITION
Quilt Artist

SELECTED EXHIBITIONS
South Bay Quilters Guild Show, Torrance Cultural Arts Center, Torrance, CA

Uhuru Guild Show, Fairfield Inn, Beltsville, MD

Threads Unraveled-Stories Revealed, New York, NY

Mayor's Office Art Gallery, Denver, CO (curator)

Koelbel Library Art Gallery, Englewood, CO (curator)

Rocky Mountain Quilt Museum, Golden, CO

National Headquarters of the National Council of Negro Women, Washington, DC

Charles Sumner School Museum and Archives, Washington, DC

SELECTED REFERENCES
Mazloomi, Carolyn, *Spirits of the Cloth: Contemporary African-American Quilts*, New York: Clarkson Potter/Publishers, 1998: 32–33, 178.

Walner, Hari, *Exploring Machine Trapunto: New Dimensions*, Lafayette, CA: C & T Pub., 1999.

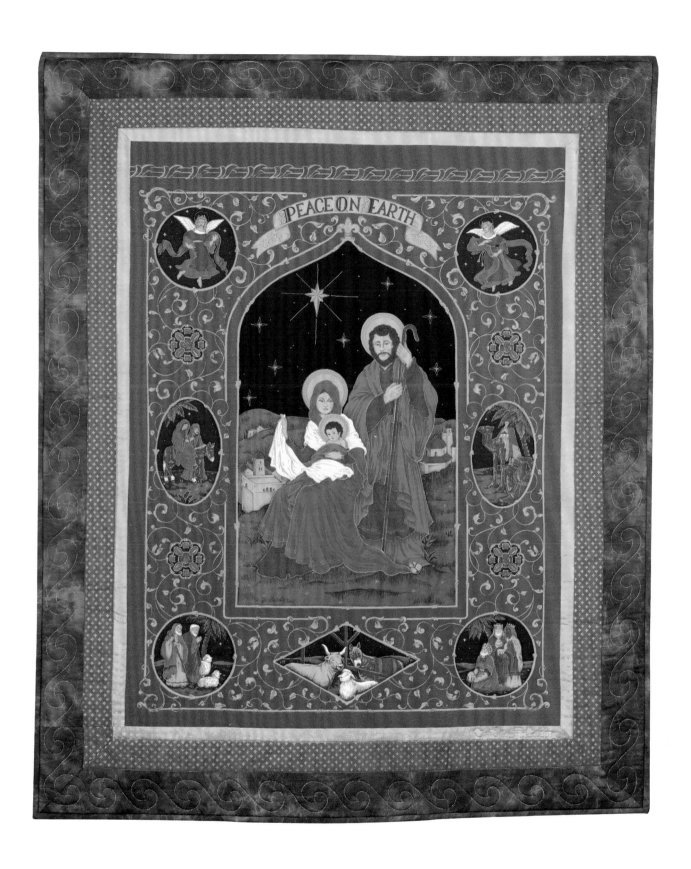

7 **PEACE AT CHRIST'S BIRTH** *1998. 48 x 40 inches.*
Cotton; machine pieced and quilted.

Theresa Polley-Shellcroft

Mary sits in deep meditation and prayer as the angel announces the conception of the Christ child. As the Holy Spirit descends, a gust of wind ruffles her hair while bells ring acknowledging the presence of the angel. In deep humility, Mary accepts the will of God in her life. On December 31, 1977, as I sat in deep prayer and meditation at a religious service, a voice revealed to my heart that I "was with child." In great disbelief, as my husband and I had been trying for eight years to have a child, I too, felt as Mary must have felt. And I too found that place of resignation in accepting the Will of the Creator as revealed unto me. My son, Christopher, was born August 31, 1978. In the design of my quilt I've tried to reveal the sacredness as well as the "other worldliness" of my experience.

LUKE 1.26–33, 38 *In the sixth month of Elizabeth's pregnancy God sent the angel Gabriel to a town in Galilee named Nazareth. He had a message for a young woman promised in marriage to a man named Joseph, who was a descendant of King David. Her name was Mary. The angel came to her and said, "Peace be with you! The Lord is with you and has greatly blessed you!"*

Mary was deeply troubled by the angel's message, and she wondered what his words meant. The angel said to her, "Don't be afraid, Mary; God has been gracious to you. You will become pregnant and give birth to a son, and you will name him Jesus. He will be great and will be called the Son of the Most High God. The Lord God will make him a king, as his ancestor David was, and he will be the king of the descendants of Jacob forever; his kingdom will never end!"

"I am the Lord's servant," said Mary; "may it happen to me as you have said." And the angel left her.

EDUCATION

1968 BS, Art Education, West Virginia State College, Institute, WV

1971 MA, Painting, Art History, Marshall University, Huntington, WV

1972–75 Graduate Studies, Art History, African American/African Art, University of Pittsburgh, Pittsburgh, PA

POSITION

Art History Instructor, Victor Valley Community College, Victorville, CA

Art Teacher, Mojave High School, Hesperia, CA

SELECTED AWARDS

2002 Who's Who Among American Teachers
 Who's Who Among American Women
 Artist in Residence, African Village Weekend, Pomona, CA

1998 Elementary Educator of the Year

SELECTED EXHIBITIONS

Sense of Fiber, dA Center for the Arts, Pomona, CA

The Red Show, dA Center for the Arts, Pomona, CA

Our Vision … An Exhibition of African American Women Artists, The Gallery on 5th, San Bernadino, CA

Beyond the Mask, Pittsburgh Center for the Arts, National Juried Show, Pittsburgh, PA

Cuttress Gallery of Art, Pomona, CA

Finding Voice, Creating Vision, National Civil Rights Museum, Memphis, TN

African and African American Images in Art and Quilts, Victor Valley Community College, Victorville, CA (curator)

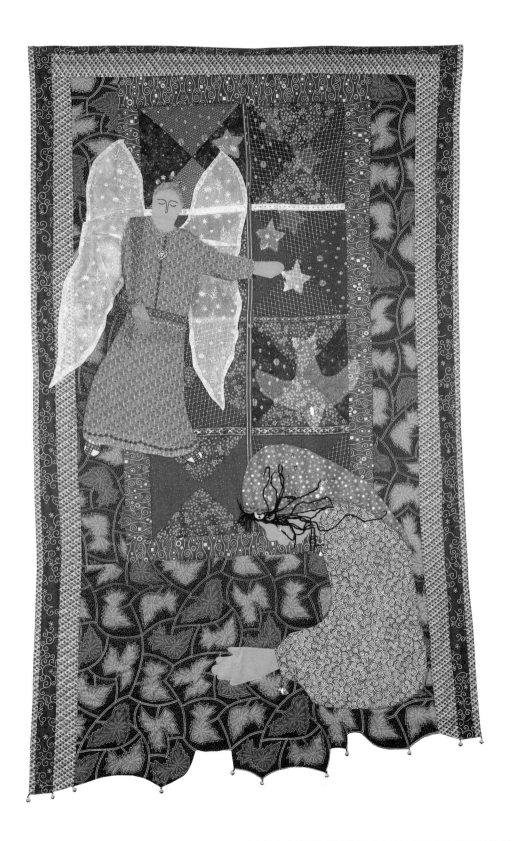

8 **THE ANNUNCIATION: BE IT UNTO ME
ACCORDING TO THY WORD** *2003. 75 x 45 inches.
Cotton, beads, sequins; appliqué and hand quilted.*

Michael Cummings

The starkness of the composition with only Christ visible creates a mystique within this abstract narrative. Being raised in a Baptist church ... always looking at portraits of a white Christ with blond hair and blue eyes I chose to create a Christ figure that has features like my own ethnic group ... an African Christ. I chose to dress him in African fabric. I was taught that we are all made in His image. Taking that belief one step further, "God is made in mankind's entire image." It's the spirit that's most important. If you look at Buddha images from different countries you will find his physical appearance reflects the country he was made in. Yet, people don't have a problem with Buddha's appearance from country to country. The early Ethiopian Christians created religious art that told biblical stories; however, the images they created looked like them. You can find the same artistic freedom in European Christian art. My ultimate goal is to have you feel the story with my quilt.

JOHN 19.16b–20 *So they took charge of Jesus. He went out, carrying his cross, and came to "The Place of the Skull," as it is called. (In Hebrew it is called "Golgotha.") There they crucified him; and they also crucified two other men, one on each side, with Jesus between them. Pilate wrote a notice and had it put on the cross. "Jesus of Nazareth, the King of the Jews," is what he wrote. Many people read it, because the place where Jesus was crucified was not far from the city. The notice was written in Hebrew, Latin, and Greek.*

EDUCATION
1974 Art Students' League, New York, NY
1980 BA, State University of New York, NY

POSITION
New York State Council on the Arts Associate, New York, NY

SELECTED COLLECTIONS
Renwick Gallery, American Art Museum, Smithsonian Institution, Washington, DC
Bill and Camille Cosby, New York, NY
Alonzo and Tracy Mourning, Miami, FL
Whoopie Goldberg, Los Angeles, CA
American Craft Museum, New York, NY
The Studio Museum in Harlem, New York, NY

SELECTED AWARDS
2003 National Underground Railroad Freedom Center, Cincinnati, Ohio (commission)
2001 Louis Comfort Tiffany Biennial Award, Louis Comfort Tiffany Foundation, Oyster Bay, NY
2000 Excellence in Design Award, City of New York Art Commission, New York, NY
2001 Children's Book of Distinction, Riverbank Review, Minneapolis, MN

SELECTED EXHIBITIONS
2001 New England Quilt Museum, Lowell, MA
2000 European Quilt Expo VII, Strasbourg, France
1997 Cincinnati Art Museum, Cincinnati, OH
1981 Yale University, New Haven, CT

SELECTED REFERENCES
Mazloomi, Carolyn, *Spirits of the Cloth: Contemporary African-American Quilts*, New York: Clarkson Potter/Publishers, 1998: 84, 140, 180.

Shaw, Robert, *The Art Quilt*, [New York]: Hugh Lauter Levin Associates, 1997.

Tobin, Jacqueline L. and Raymond G. Dobard, *Hidden in Plain View: The Hidden Story of Quilts and the Underground Railroad*, New York: Doubleday, 2000.

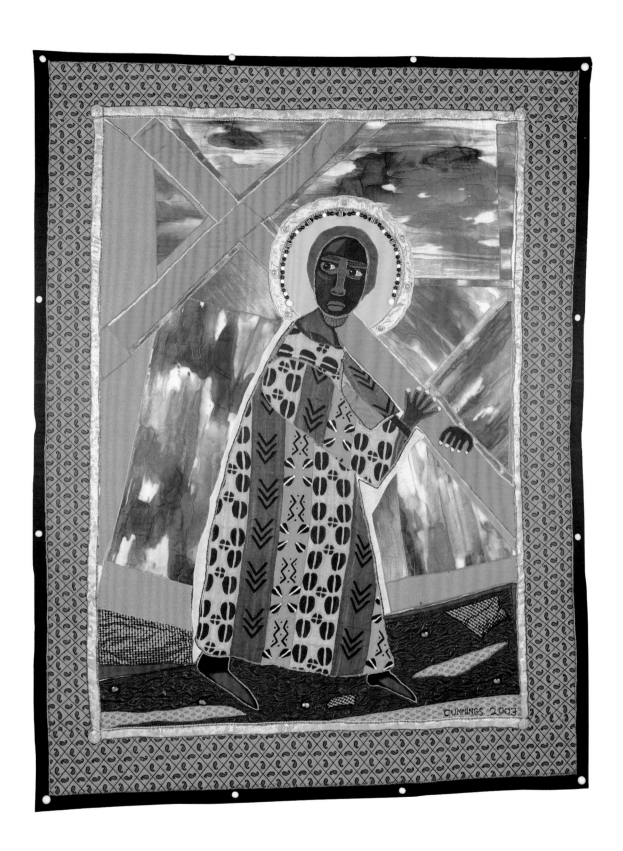

9 **CHRIST BEARING THE CROSS** *2003. 91 x 71 inches. Cotton, linen; machine appliqué and quilted.*

Phyllis Stephens

When I think of loved ones that have passed on, before I allow the sadness of my loss to capture me, I think of my grandfather's final and farewell sermon. It was entitled "This Place is Not My Home." He explained: "If you should look for him and he's gone, don't cry, cause he had been working on a building not made by man." In my lowest hour I have remembered his words. It gives me comfort to know my loved ones are safe in a place that God has prepared for each of them.

JOHN 14.1–3 *"Do not be worried and upset," Jesus told them. "Believe in God and believe also in me. There are many rooms in my Father's house, and I am going to prepare a place for you. I would not tell you this if it were not so. And after I go and prepare a place for you, I will come back and take you to myself, so that you will be where I am."*

EDUCATION
Boston University, Boston, MA

POSITION
Artist

SELECTED COLLECTIONS
The Women's Medical Center, Kennesaw, GA
Black Enterprise, New York, NY
Girls, Inc., Smyrna, GA

SELECTED AWARDS
2001 Georgia Council for the Arts Advisory Award
1998 National Association of 100 Black Women, Artist of the Year
 American Story Quilt Achievement Award

SELECTED EXHIBITIONS
2002 Chattanooga African-American Museum, Chattanooga, TN
2000 The Nyumburu Black History Museum, Silver Spring, MD
1999 The Renaissance Center, Dickson, TN
1998 The APEX Museum, Atlanta, GA

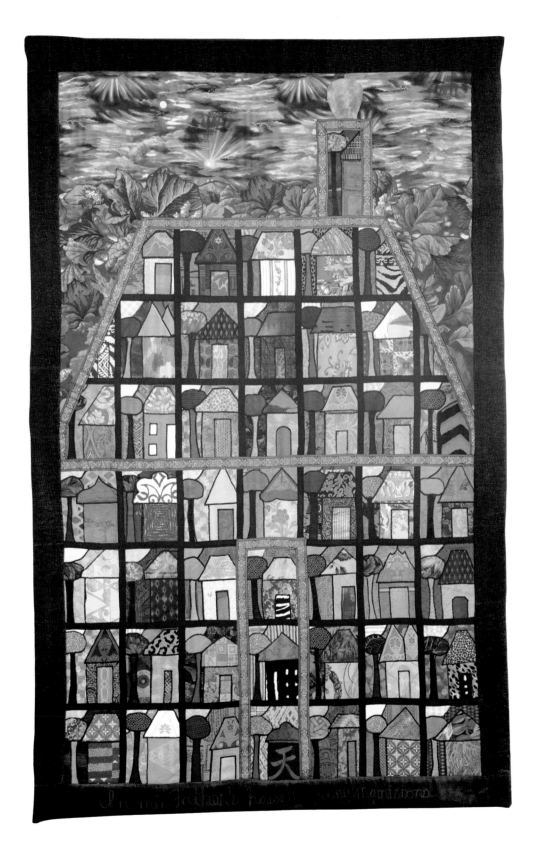

10 **A PLACE FOR YOU** *2002. 92 x 60 inches.*
Cotton; appliqué, quilted.

Marlene O'Bryant-Seabrook

The quilt was inspired by Michelangelo's fifteenth-century statue *Pietà*. A tear rolls down her cheek while Mother Mary tenderly holds her crucified son Jesus. The background is somber, but his feet break through onto the "sunshine" border, which represents the Resurrection and the promise of eternal life for his followers.

The *Pietà* has been one of my favorite works of art since taking Art 101 as a college freshman. As I thought of potential ideas for a religious themed quilt, it came to mind. As I repeatedly looked at a photo prior to preparing my working sketch, I began to see it in a different light. Michelangelo was a great artist, but he was NOT a mother. His statue shows Jesus with His head tilted back so that His face is barely visible. Mary, with her head slightly bowed (eyes appear closed), has her opened left hand extended. In *A Mother's Vigil*, I changed the position of the head of Jesus so that Mother Mary – in this final physical contact with her child – is looking at His face while tenderly holding His left arm in her hand.

JOHN 19.25–30 *Standing close to Jesus' cross were his mother, his mother's sister, Mary the wife of Clopas, and Mary Magdalene. Jesus saw his mother and the disciple he loved standing there; so he said to his mother, "He is your son."*

Then he said to the disciple, "She is your mother." From that time the disciple took her to live in his home.

Jesus knew that by now everything had been completed; and in order to make the scripture come true, he said, "I am thirsty."

A bowl was there, full of cheap wine; so a sponge was soaked in the wine, put on a stalk of hyssop, and lifted up to his lips. Jesus drank the wine and said, "It is finished!"

Then he bowed his head and gave up his spirit.

EDUCATION

1955 BS, South Carolina State College (University), Orangeburg, SC

1972 MA, Teaching, The Citadel, Charleston, SC

1975 PhD, University of South Carolina, Columbia, SC

POSITION
Educator (retired)

SELECTED EXHIBITIONS

2001 *A Communion of the Spirits*, Mississippi Museum of Art, Jackson, MS; National Civil Rights Museum, Memphis, TN (traveling)

1993 *Uncommon Beauty in Common Objects: The Legacy of African American Craft Art*, National Afro-American Museum and Cultural Center, Wilberforce, OH (traveling)

 African American Fiber Artisans: Spirit of the Cloth, Frank Hale Cultural Center, Worthington, OH (traveling)

1992 *Loving Hands*, Manhattan East Gallery of Fine Arts, New York, NY

1991 Avery Research Center for African American History and Culture, College of Charleston, SC

SELECTED REFERENCES
Freeman, Roland L., *A Communion of the Spirits: African-American Quilters, Preservers, and Their Stories*, Nashville, TN: Rutledge Hill Press, 1996: 338–41.

Lavitt, Wendy, *Contemporary Pictorial Quilts*, Layton, UT: Gibbs Smith, 1993: 74, 78.

Mazloomi, Carolyn, *Spirits of the Cloth: Contemporary African-American Quilts*, New York: Clarkson Potter/Publishers, 1998: 51, 186.

Moore, Dottie and Michael Harrison, *Lives in Process: Creativity in the Second Fifty Years*, San Carlos, CA: Ladybug Press, 2002: 27, 57–58.

11 **A MOTHER'S VIGIL** *2003. 72 x 52. Hand-dyed cotton, commercial cottons, nylon netting, yarn; machine pieced, hand appliqué and quilted.*

Cathleen Richardson Bailey

This Bible verse reminded me that God is the original artist and innovator. He needed no one to instruct Him on how to make a snowflake and in a flash of genius made them different. He created the color green and flung it, as multifaceted shades, into the forest. I'm stirred up by the Almighty who gave me breath and inspires me.

JOB 33.4 *God's spirit made me and gave me life.*

POSITION
Writer

SELECTED AWARDS

2003 Pennsylvania Council on the Arts Fellowship in Literature, Fiction

1987 Second Prize, Composition Program Writing Awards, Department of English, University of Pittsburgh, PA

SELECTED EXHIBITIONS

2003 *Quilters and Preservers of Western Pennsylvania*, Senator John Heinz Pittsburgh Regional History Center, Pittsburgh, PA

2002 *Finding Voice, Creating Vision*, National Civil Rights Museum, Memphis, TN

2001 *Perspectives*, City County Building, City of Pittsburgh, PA (curator)

Threads of Freedom: The Underground Railroad Story in Quilts, Firelands Association for the Visual Arts and Oberlin Historical and Improvement Organization, Oberlin, OH

2000 *I Can Still Quilt Without My Glasses*, Associated Artists of Pittsburgh, PA (curator)

Artisans: Slave Antique and Contemporary, Merrick Art Gallery, New Brighton, PA (curator)

A Gathering of Women, A Healing Place: 1000 Expressions of Life, The Abington Art Center, Jenkintown, PA (traveling)

1999 *Spirits of the Cloth: Contemporary Quilts by African American Artists*, American Craft Museum, New York, NY (traveling)

SELECTED REFERENCES

Mazloomi, Carolyn, *Spirits of the Cloth: Contemporary African-American Quilts*, New York: Clarkson Potter/Publishers, 1998: 69, 155, 175.

Towner-Larsen, Susan and Barbara Brewer Davis, *With Sacred Threads: Quilting and the Spiritual Life*, Cleveland: United Church Press, 2000: 19–20.

Text on the artwork:

It is the Spirit of God that made me, which has stirred me up; and the breath of the Almighty that gives me life, which inspires me.
Job 33:4
Amplified Bible.

12 **STIRRED UP** *2003. 21 x 34 inches. Cotton, acrylic paint, glitter, sequins and beads; appliqué, stump work, hand embroidery.*

Myrah Brown Green

This quilt is based on one of my favorite scriptures. Ecclesiastes 3.4. I use the passage to remind my children and me that there is a time for everything in life. The tree symbolizes life everlasting. The tree and leaves are symbols I use quite often in other quilt creations.

ECCLESIASTES 3.1–4 *Everything that happens in this world happens at the time God chooses. He sets the time for birth and the time for death, the time for planting and the time for pulling up, the time for killing and the time for healing, the time for tearing down and the time for building. He sets the time for sorrow and the time for joy, the time for mourning and the time for dancing ...*

EDUCATION

1974–76	Boston University, Boston, MA
1979	BFA, Pratt Institute, Brooklyn, NY
2004	PhD, The Union Institute and University, Cincinnati, OH

POSITION

1980 to present, Co-Founder/Program Coordinator, Crown Heights Youth Collective, Inc., Brooklyn, NY

1991 to present, Founder/Principal, Collective Fellowship and Peace Academy, New York, NY

SELECTED COLLECTIONS

Satta Gallery, Brooklyn, NY

Crown Heights Youth Collective, Brooklyn, NY

SELECTED AWARDS

2002	Key to the City of Cambridge, MA
2000	Third Place, Vertigo Studios, Memphis, TN

SELECTED EXHIBITIONS

2003	*I Remember Mama: The Hand that Rocks the Cradle*, Quilt, Inc., Houston, TX
2002	*Finding Voice, Creating Vision*, National Civil Rights Museum, Memphis, TN
	Stitching Justice: Unlocking Our Hearts, Minds and Souls, The Nathan Cummings Foundation, New York, NY
2001	*Threads of Freedom: The Underground Railroad Story in Quilts*, Firelands Association for the Visual Arts and Oberlin Historical and Improvement Organization, Oberlin, OH
	Six Continents of Quilts, The American Craft Museum, New York, NY
2000	*Roots of Racism: Ignorance and Fear*, Vertigo Studios, Memphis, TN
1999	*Spirits of the Cloth: Contemporary Quilts by African American Artists*, The American Craft Museum, New York, NY (traveling)

SELECTED REFERENCES

Mazloomi, Carolyn, *Spirits of the Cloth: Contemporary African-American Quilts*, New York: Clarkson Potter/Publishers, 1998: 37, 177.

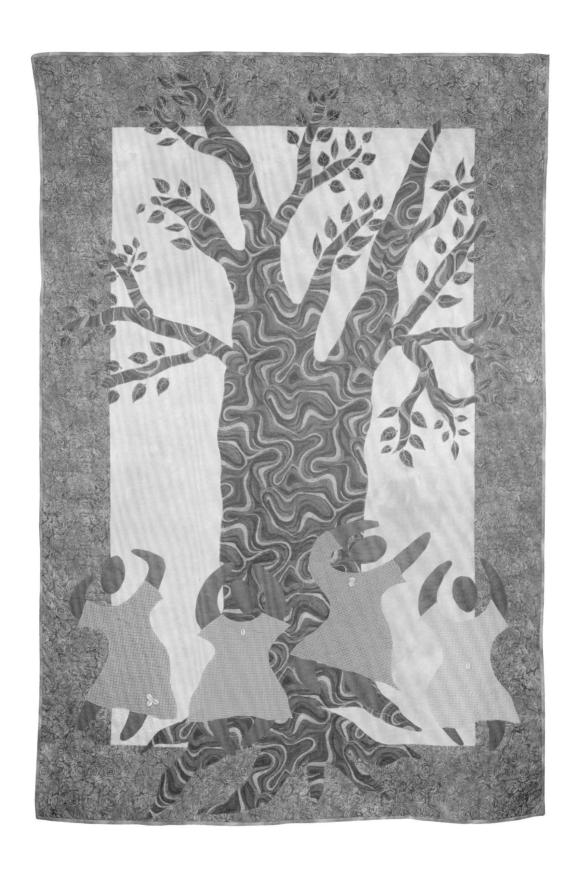

13 **AND A TIME TO DANCE** *2003. 87 x 60 inches.*
Cotton; machine appliqué and quilted.

Bearing
Witness

Yvonne Wells

Many aspects of being a woman are shown in this quilt: graduate, businesswoman, mother, and domestic. She wears a cross over her heart indicating her faith in the Lord.

EDUCATION

1964 BS, Stillman College, Tuscaloosa, AL

1975 MS, Alabama State University, Montgomery, AL

POSITION

Teacher, Tuscaloosa City School System (retired)

SELECTED COLLECTIONS

Birmingham Museum of Art, Birmingham, AL

International Quilt Study Center, University of Nebraska–Lincoln, Lincoln, NE

Collection of the Governor's Mansion, Montgomery, AL

SELECTED AWARDS

1999 Best of Show (Folk Art), Festival of Folk Life, Columbus, GA

1994–96, Best of Show, Kentuck Festival of the Arts,
1991 Northport, AL

SELECTED EXHIBITIONS

2002 *Quilts: Yvonne Wells, Celebrating Women's History Month*, Wynn Center, Stillman College Gallery of Art, Tuscaloosa, AL

2001 *Women Folk: Of Courage & Community*, Jeanine Taylor Folk Art Gallery, Winter Park, FL

1994 *Whose Broad Stripes and Bright Starts: Death, Reverence, and the Struggle for Equality in America*, Betty Rymer Gallery at The School of the Art Institute of Chicago, Chicago, IL

1989 *Stitching Memories: African-American Story Quilts*, Williams College, Williamstown, MA

SELECTED REFERENCES

Freeman, Roland L., *A Communion of the Spirits: African-American Quilters, Preservers, and Their Stories*, Nashville: Rutledge Hill Press, 1996: 190–94.

Kemp, Kathy, *Revelations: Alabama's Visionary Folk Artists*, Birmingham: Crane Hill Publishers, 1994: 208–11.

Lavitt, Wendy, *Contemporary Pictorial Quilts*, Layton, UT: Gibbs Smith, 1993.

Wahlman, Maude Southwell, *Signs and Symbols: African Images in African-American Quilts*, New York: Studio Books in association with Museum of American Folk Art, 1993.

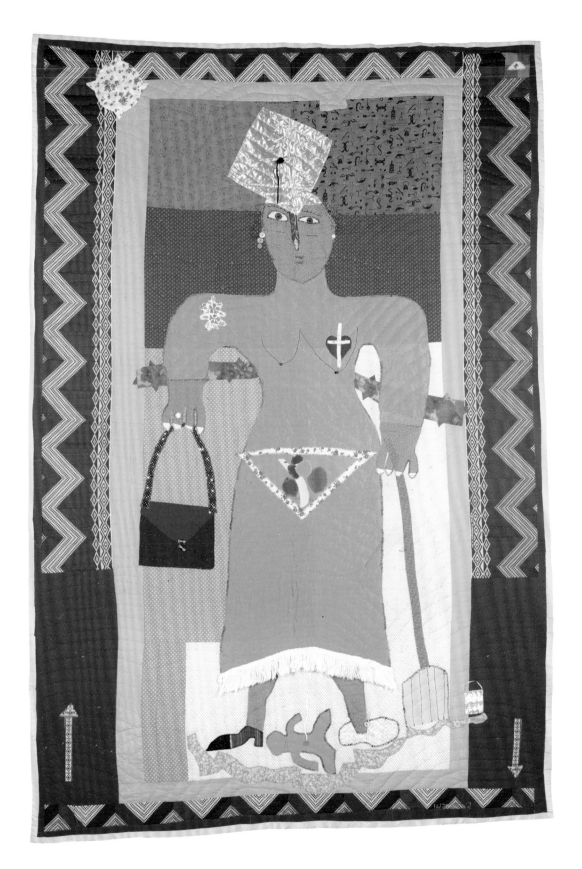

14 **WOMAN I AM** *2002. 101 x 69 inches. Cotton;
hand appliquéd and hand quilted.*

Gwendolyn Aqui

My quilt represents a woman who's faced many trials and tribulations. It's because of her faith that she has been able to make it through this sometimes cruel statement of affairs we call "life." The water at the bottom represents her baptism. The sides of the work look like stained glass windows of the church she attends. Her face is two colors. Blue represents her past pain; purple represents her new life with Jesus. She has now found peace and joy.

EDUCATION

1972 BA, Howard University, Washington, DC

1974 MA, Teaching, Trinity College, Washington, DC

POSITION

Art Consultant, Art on Wheels, Greenbelt, MD

SELECTED AWARDS

2003 Artist in Residence, Vermont Studio Center, Johnson, VT

Palette and Pen Award, Arts and Letters Committee, Prince George's County Alumnae Chapter of Delta Sigma Theta Sorority

2002 Maryland State Arts Council Individual Artist Award in Visual Arts

2001 Award from the National Museum of African Art, Washington, DC

SELECTED EXHIBITIONS

2003 *Grant Exhibition*, Maryland State Arts Council, Baltimore, MD

2002 *Visions Through Color*, Arts Club of Washington, Monroe Gallery, Washington, DC (solo)

Transformation, Sassafrass, Baltimore, MD (solo)

A Group Like Us, Sassafrass, Baltimore, MD

1999 *Why Jazz?*, Benneker-Douglass Museum, Annapolis, MD

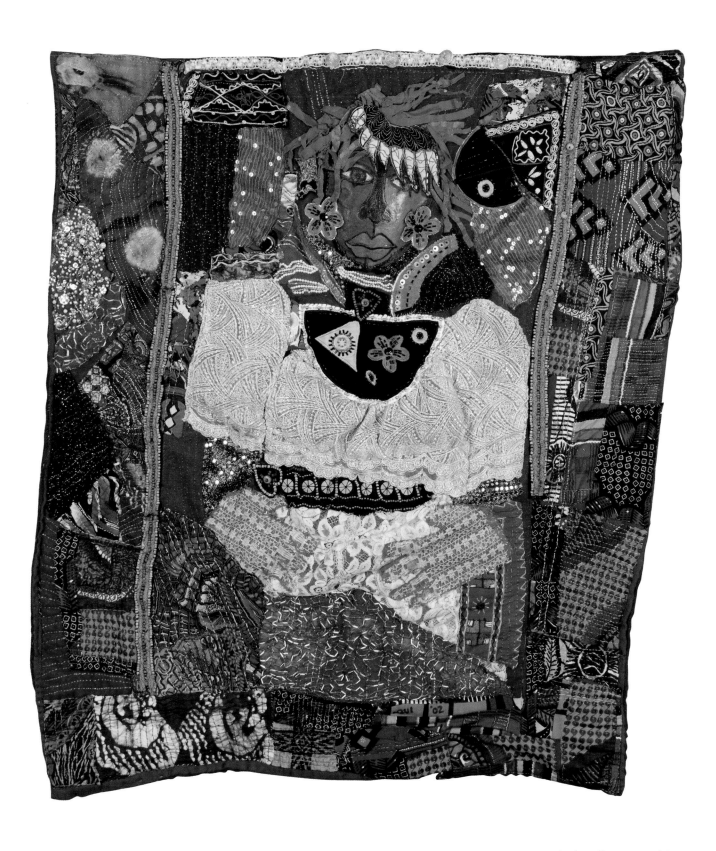

15 **SPIRIT WOMAN** *2003. 34 x 31 inches. Cotton; machine appliquéd and quilted.*

Anita Knox

Tranquility is a quilt that evolved differently from my original quilt design. Originally a star hung over the figures, showering light over each member of the Holy Family, but the direction of the design changed. I even decided there needed to be a change in fabrics. I stopped working on the quilt for several days, went back to my stash, and found this great satin fabric my mother had given me. The texture and feel of the cloth moved me to eliminate the star and focus on the richness of the satin and the other new fabrics I selected. The sumptuous color and feel of the fabrics to me is synonymous with richness of family faith, love, and unity. The quilt is embellished with a variety of buttons and combines trapunto and machine and hand quilting. It took about two years to complete this quilt.

EDUCATION
1975 BFA, Howard University, Washington, DC
1997 MFA, Memphis College of Art, Memphis, TN

POSITION
Adjunct Art Instructor, Tarrant County College, Fort Worth, TX

SELECTED COLLECTIONS
Kansas African American Museum, Wichita, KS
South Dallas Cultural Center, Dallas, TX
The Black Academy of Arts and Letters, Dallas, TX

SELECTED EXHIBITIONS
2003 *Sisters on the Horizon*, South Dallas Cultural Center, Dallas, TX

2002 *Finding Voice, Creating Vision*, National Civil Rights Museum, Memphis, TN

2001 *A Flowering of Their Souls*, The Black Academy of Arts and Letters, Dallas, TX

2000 *Remembering the Legacy*, Historically Black Colleges Faculty Exhibition, in conjunction with the National Black Arts Festival, Morris Brown College, Atlanta, GA

1999 *Sacred Imagery in African American Quilts and Textiles*, Kansas African American Museum, Wichita, KS (solo)

 Spirits of the Cloth: Contemporary Quilts by African American Artists, American Craft Museum, New York, NY (traveling)

1995 *Uncommon Beauty in Common Objects: The Legacy of African American Craft Art*, National Afro-American Museum and Cultural Center, Boston, MA (traveling)

SELECTED REFERENCES
Ayars, Mimi, "From Surface Painter to Art Quilter," *American Quilter Magazine*, Spring 2003, vol. XIX no. 1: 16–18.

Bilik, Jen, ed., *Women of Taste: A Collaboration Celebrating Quilt Artists and Chefs*, Lafayette, CA: C & T Pub., 1999: 50–51.

Freeman, Roland L., *A Communion of the Spirits: African-American Quilters, Preservers, and Their Stories*, Nashville, TN: Rutledge Hill Press, 1996: 208–9, 211.

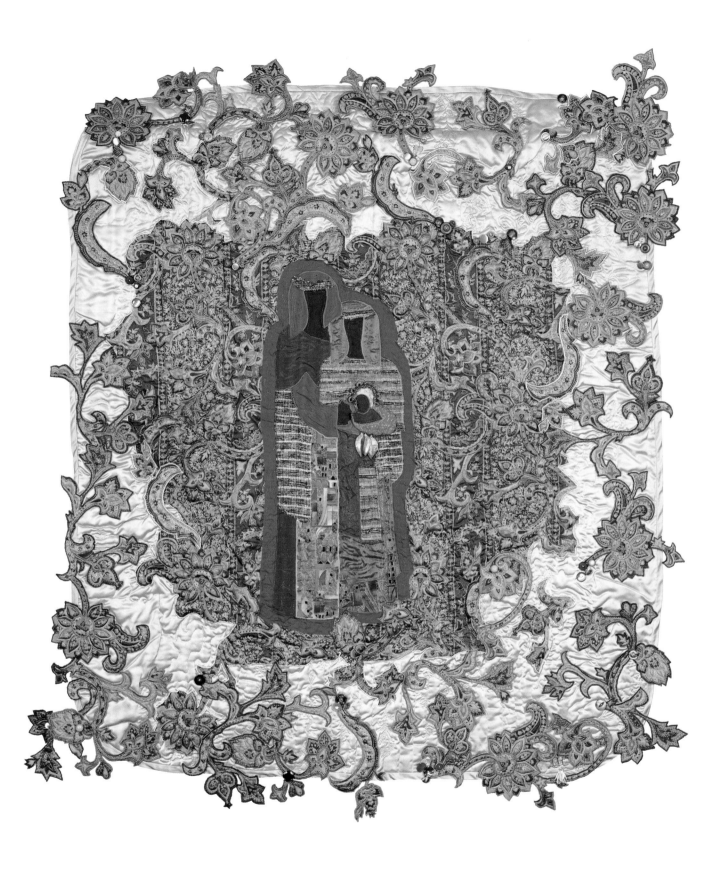

16 **TRANQUILITY** *1998. 60 x 54 inches. Cotton, silk, buttons, beads; hand and machine appliqué, hand and machine quilted.*

Sherry Whetstone-McCall

Within two years, two generations of strong women crossed over to experience their spiritual journey. Mother Dear, the eldest of seven siblings, passed on first. My Grandmother, Lillie Champy Bowman, the youngest of the seven and also the loan survivor, died nine months later. My mother Johnnie Champy Whetstone passed on four months after my grandmother. This quilt depicts the strong line of Champy and Whetstone women. They are my ancestors of past generations and women of our future generation. Depicted here are four generations of women with strength, courage, intelligence, and hope.

EDUCATION
1976–78 Cameron University, Lawton, OK
1981 BS, Oklahoma State University, Stillwater, OK
1994–96 Maplewoods Community College, Kansas City, MO

POSITION
Artist

SELECTED AWARDS
1996 Artistic Merit Award, Women's Works '96, Ninth Annual Exhibit of Fine Art by Women, Woodstock, IL
1994 Artistic Merit Award, Oklahoma Art Guild Regional Art Show, Oklahoma City, OK

SELECTED EXHIBITIONS
2003 *Women in Cloth*, Bruce Watkins Cultural Heritage Center, Kansas City, MO
2002 *Threads of Africa II*, Lincoln Library, Jefferson City, MO
2001 *Tell Me a Story – Chapter 1: Narrative Themes in Contemporary Fabric Arts*, Cahoon Museum of American Art, Cotuit, MA
 A Communion of the Spirits: African-American Quilters, Preservers, and Their Stories, Arts and Industries Museum, Smithsonian Institution, Washington, DC
1999 *Spirits of the Cloth: Contemporary Quilts by African American Artists*, American Craft Museum, New York, NY (traveling)
1997 *Daughters of Harriet Powers*, Museum of African American Art, Tampa, FL

SELECTED REFERENCES
Bilik, Jen, ed., *Women of Taste: A Collaboration Celebrating Quilt Artists and Chefs*, Concord, CA: C & T Pub., 1999: 232–33.

Freeman, Roland L., *A Communion of the Spirits: African-American Quilters, Preservers, and Their Stories*, Nashville: Rutledge Hill Press, 1996, 232–33, 381.

Mazloomi, Carolyn, *Spirits of the Cloth: Contemporary African-American Quilts*, New York: Clarkson Potter/Publishers, 1998: 16–17, 52, 59, 88, 190, 197.

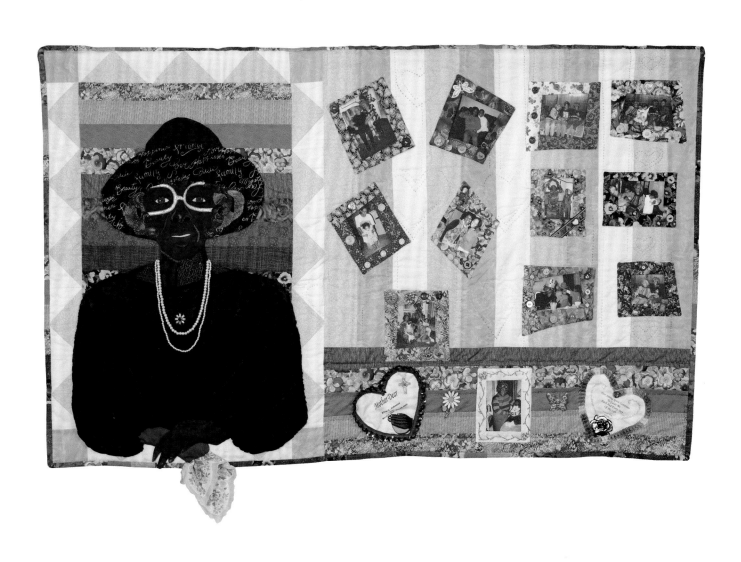

17 **MOTHER DEAR, OUR MATRIARCH** *2003.*
37 x 54 inches. Cotton, beads, shells; machine appliqué
and quilted.

Michele David

This quilt was inspired by African American women going to church with their fabulous hats and love of Bible stories.

EDUCATION

1988 MD, University of Chicago, Chicago, IL

1996 MPH, Harvard University, Cambridge, MA

POSITION

Assistant Professor of Medicine, Boston University Medical School, Boston, MA

Co-Director, Haitian Health Institute at Boston Medical Center, Boston, MA

SELECTED AWARDS

2000 Outstanding Physician Award, Harvard Pilgrim Health

SELECTED EXHIBITIONS

2003 *NY Quilts!*, Russell Sage College, Troy, NY

First Parish, Brookline, MA

2002 Massachusetts Medical Society Annual Art Exhibit, Nashua, NH

2000 Boston University Art Exhibit, Boston, MA

SELECTED REFERENCES

"Creations. Metamorphosis," *Unitarian Universalist World Magazine*, vol. XVII, 2003, No. 3: 15.

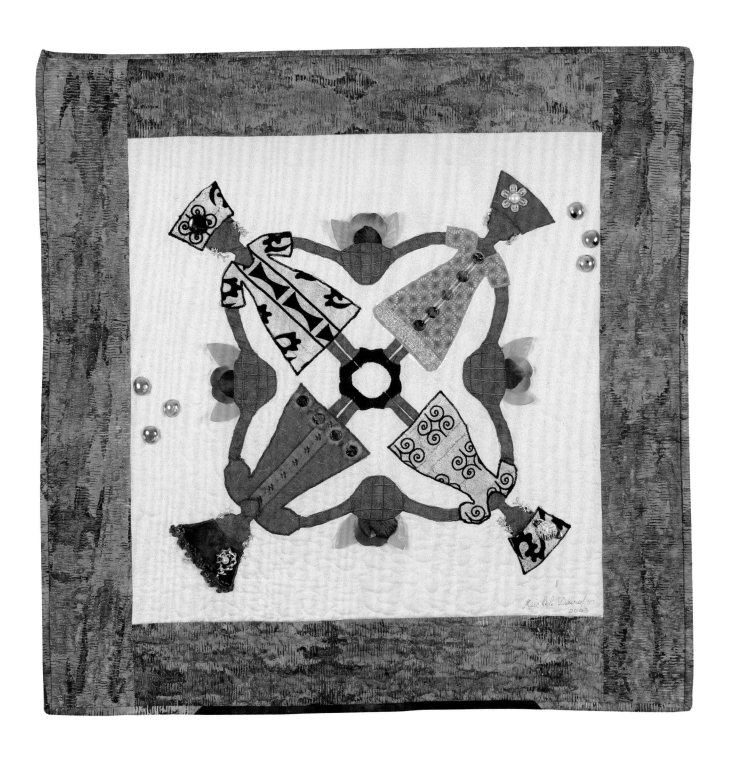

18 CHURCH LADIES *2002. 28 x 28 inches. Commercial cotton fabrics, cotton thread; machine appliqué and quilted.*

Barbara G. Pietila

The bonds between father and daughter are often the strongest and most enduring. He protects and nurtures, loves and provides for her from the day of her birth until he reluctantly turns her over to another. He's there for all the stages and special moments of her life and in later years she is there for him. Her gift to him, in addition to her love, is the perpetuation of the family with the gift of grandchildren.

POSITION
President, African American Quilters of Baltimore

SELECTED COLLECTIONS
Weinberg Medical Center, Baltimore, MD

SELECTED EXHIBITIONS
2002 *Stories in Art*, Middlebury College Museum
 of Art, Middlebury, VT

1999 *Spirits of the Cloth: Contemporary Quilts by
 African American Artists*, American Craft
 Museum, New York, NY (traveling)

1998 *Stitches and Stories*, The African American
 Museum, Philadelphia, PA

 A Common Thread, The James E. Lewis
 Museum of Art, Morgan State University,
 Baltimore, MD

1996 *Spirit of the Cloth: African-American Story
 Quilts*, Wadsworth Atheneum, Hartford, CT

1994 *More Than Something to Keep You Warm:
 Traditions and Change in African American
 Quilting*, Hampton University Museum,
 Hampton, VA

1993 *The Weaving of African American Women's
 Experience: A Celebration of Their Stories and
 Quilts*, National Civil Rights Museum,
 Memphis, TN

SELECTED REFERENCES
Fett, Sharla M., *Working Cures: Healing, Health,
and Power on Southern Slave Plantations*, Chapel Hill:
University of North Carolina Press, 2002.

Freeman, Roland L., *A Communion of the Spirits:
African-American Quilters, Preservers, and Their Stories*,
Nashville: Rutledge Hill Press, 1996: 104–05,
114–15, 373.

Lavitt, Wendy, *Contemporary Pictorial Quilts*, Layton,
UT: Gibbs Smith, 1993.

Mazloomi, Carolyn, *Spirits of the Cloth: Contemporary
African-American Quilts*, New York: Clarkson
Potter/Publishers, 1998: 53, 54–55, 150–51, 187.

Shaw, Robert, *The Art Quilt*, [New York]: Hugh
Lauter Levin Associates, 1997.

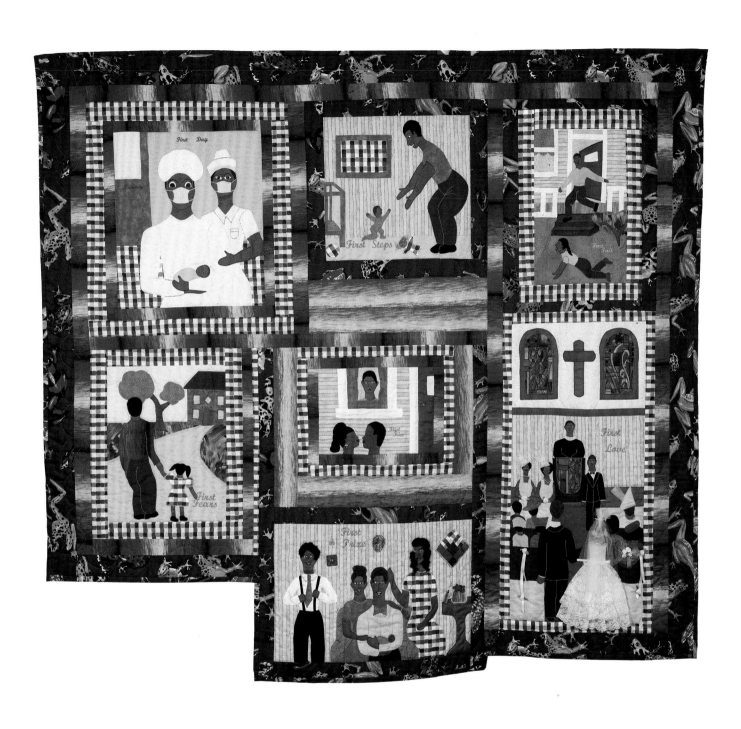

19 **COLOR HIM FATHER** *1998. 53 ¼ x 58 inches.*
Cotton; hand and machine appliqué, hand and
machine quilted.

Marla Jackson

A woman holds her firstborn son directing him toward the sky. Everyone knows that children shape the future of the world. A couple jumps the broom, a part of their marriage ceremony. This quilt was inspired by my recollections of my first child and the sacredness of giving birth.

EDUCATION
2001 Stafford Career Institute, Certificate in Interior Decorating

POSITION
Residential Supervisor, Quilting Instructor, Cottonwood, Inc.

SELECTED AWARDS
2003 Mini Fellowship, Kansas Arts Commission, Topeka, KA

SELECTED EXHIBITIONS
2003 *Voices of the Cloth: African American Quilt Exhibit*, Watkins Community Museum of History, Lawrence, KS (curator)

2002 *Underground Railroad Exhibition*, Hallmark Corporate Gallery, Lawrence, KS

2001 *Truth of Soul*, Watkins Community Museum of History, Lawrence, KS

SELECTED REFERENCES
Biles, Jan, "Stitching an African-American Legacy," *Lawrence Journal World*, October 28, 2001.

Merkel-Hess, Matt, "Quilts Detail Artist's Connection to Slavery," *Lawrence Journal World*, December 10, 2001.

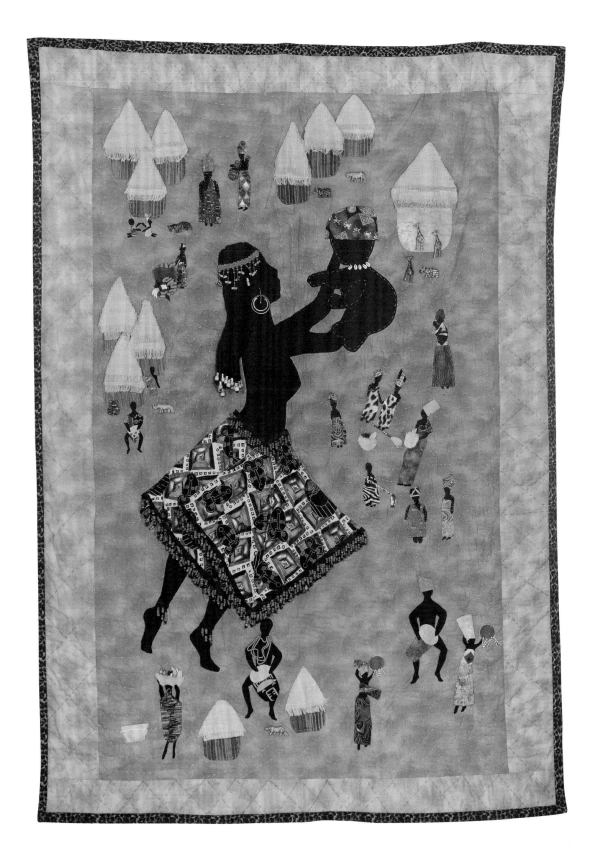

20 **FIRST BORN** *2002. 77 x 54½ inches. Cotton, beads,
plastic, canvas, wooden cutouts; hand appliqué, hand and
machine quilted.*

Diane Pryor-Holland

The piece celebrates the kindred spirituality of womanhood. It symbolizes our strength, stability, fortitude, and courage. We are blessed despite difficult circumstances, yet we don't take time to appreciate ourselves or to lift the spirit of one another. When women look at this piece, I want them to remember to count their blessings and be thankful for who they are.

EDUCATION

Current	BA Degree Candidate, City College of New York, New York, NY
2001	Fabric Dying, Emelia Gyamfi, Accra, Ghana
2002	Art Quilt Construction Residency, Tugaloo Art Colony, Jackson, MI
2003	Color Depth and Illusion in Quilting, Esterita Austin, New York, NY

POSITION

Quilt Instructor, Jamaica Center for Arts & Learning, New York, NY

Quilt Coordinator, Artists Care World Trade Disaster Relief Efforts, New York, NY

SELECTED COLLECTIONS

Queens Borough Public Library, New York, NY

SELECTED EXHIBITIONS

Ebony Quilters of Southeast Queens, Queens Borough Public Library, New York, NY

Cultural Contacts International, Suzdal, Russia

ABC Television Executive Gallery, New York, NY

York College, York, PA

21 **HER COAT OF ARMS** *1999. 49 x 70 inches. Cotton, beads, cowrie shells; hand appliqué and quilted.*

Dindga McCannon

My work is a fusion of my fine arts training (painting, drawing, and printmaking) and the usage of so-called crafts or women's work, passed down to me through my mother and grandmother: sewing, embroidery, and making stuff. I consider myself a multi-media artist who uses paint, cloth, beads, and threads to express stories, statements, or ideas. My work is afrocentric and women-centered. Although I've been working on my art for the past 38 years, I find it amazing that there's still so much to do and learn.

This quilt is a thank-you note to the many African American women who have toiled and struggled to accomplish fantastic things against all odds. Their faith in God and themselves gave them the strength to push barriers, and when knocked down, to rise like the phoenix. Their threads of faith have been passed down to me and the women of my generation so that we too may soar and open the doors for the women who come after us.

POSITION
Artist

SELECTED COLLECTIONS
The Studio Museum in Harlem, New York, NY
Schomburg Center for Research in Black Culture, New York, NY

SELECTED AWARDS
2001 Stitch in Time, Judges Choice, Wearable Art, International Quilt Association, Houston, TX

SELECTED EXHIBITIONS
1999 *Spirits of the Cloth: Contemporary Quilts by African American Artists*, American Craft Museum, New York, NY (traveling)

1998 *Black Creativity Prism*, Museum of Science and Industry, Chicago, IL

1997 *Visions Speaking to the Soul*, Schomburg Center for Research in Black Culture, New York, NY

1993 *Uncommon Beauty in Common Objects: The Legacy of African-American Craft Art*, National Afro-American Museum and Cultural Center, Wilberforce, OH

SELECTED REFERENCES
Mazloomi, Carolyn, *Spirits of the Cloth: Contemporary African-American Quilts*, New York: Clarkson Potter/Publishers, 1998: 23, 60–61, 185.

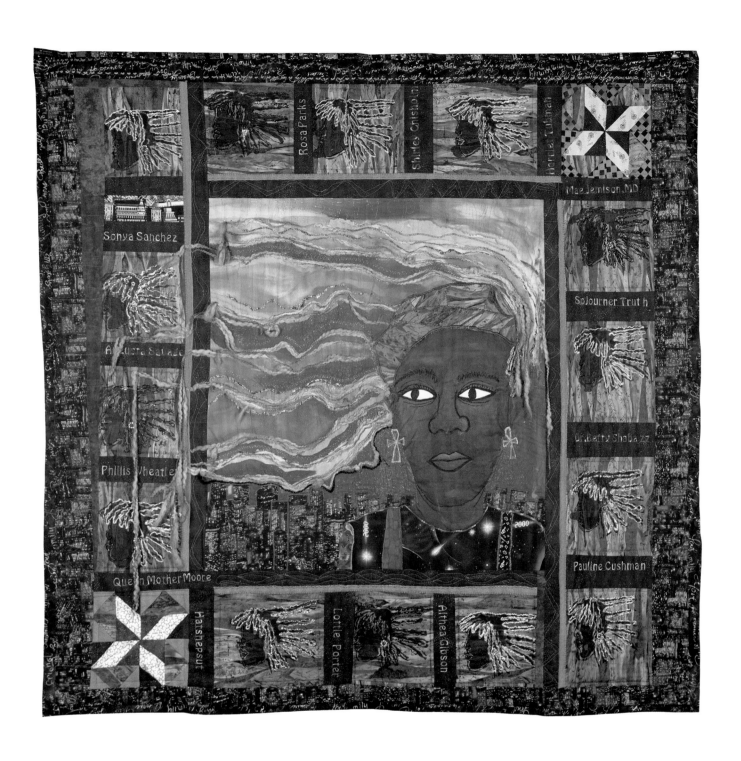

22 THREADS OF THE PAST, INSPIRATION FOR THE FUTURE *2003. 54 x 56 inches. Silkscreen, acrylic paint; machine embroidered, machine quilted.*

Dindga McCannon

These women are two ladies who went out Saturday
night and hung out all night and now they are rushing
home because they gotta go to church on Sunday morn-
ing. More than that, they realize that Sunday is not the
only day to praise the Creator, this is a seven day 24
hour type of thing. They are following traditions passed
down since slavery times: living a life filled with faith,
but on Sunday everything stops and everyone heads
out to church, where one gets a faith recharge and then
you are able to make it through the week. Life is not
easy for many of us and without this undying faith,
where would we be?

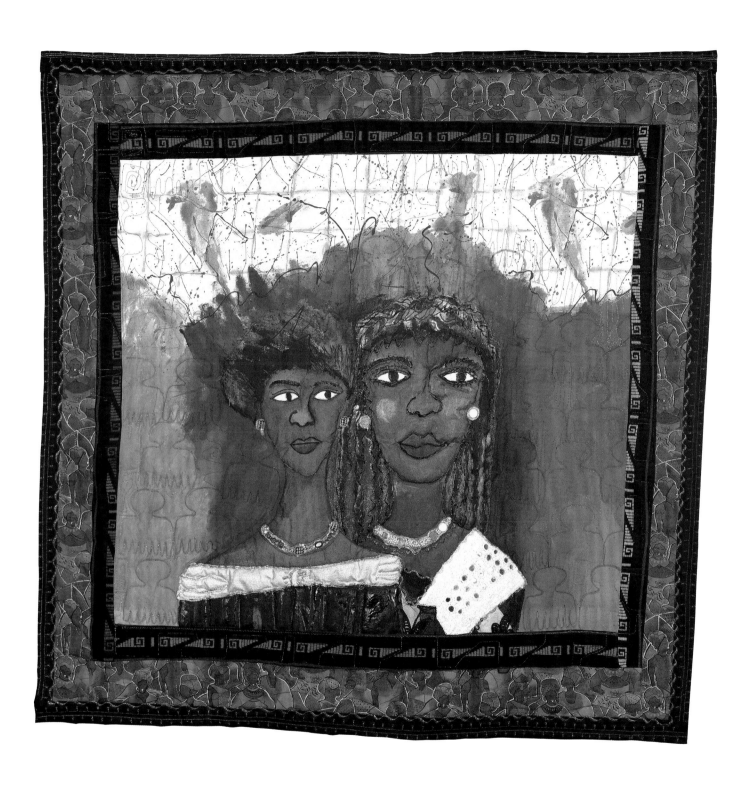

23 **SISTERS IN THE SPIRIT** *2003. 40 x 42 inches.*
Cotton, acrylic paint, antique mirrors, rayon and metallic
threads; appliqué and machine quilted.

Hope: The Anchor of Our Souls

Frances Hare

Each person's spiritual journey is different. The roads they may take, the lessons learned – all provide unique experiences.

EDUCATION
1974 BA, State University College at Buffalo, Buffalo, NY

POSITION
Dancer

SELECTED AWARDS
2001 First Prize, Innovative Quilts

1997 First Prize, Innovative Quilts

SELECTED EXHIBITIONS
2001 State University College at Buffalo, Buffalo, NY

1999 *Spirits of the Cloth: Contemporary Quilts by African American Artists*, American Craft Museum, New York, NY (traveling)

SELECTED REFERENCES
Mazloomi, Carolyn, *Spirits of the Cloth: Contemporary African-American Quilts*, New York: Clarkson Potter/Publishers, 1998: 74–75, 138–39, 181.

24 **WANDERING FACES FACING SECRETS SEEKING WONDER** *2000. 56 x 68 inches. Cotton; collage, machine quilted.*

Viola Burley Leak

Everybody has a second chance to make things right. I strongly believe that people can be redeemed. Redemption is about second chances. This quilt portrays man's freeing and salvation from Original Sin, the tasting of the forbidden fruit by Adam and Eve. The top portion of the quilt represents the ascension into grace and light. The mid-section shows Adam and Eve along with anguished souls resting on top of a coiled serpent. The bottom portion depicts people praying for those in agony. An apple rests at the bottom of the quilt.

EDUCATION

1965 BA, Art, Fisk University, Nashville, TN

1968 BFA, Fashion Design, Pratt Institute, New York, NY

1973 MA, Creative Arts, Hunter College, New York, NY

1985 MFA, Printmaking, Howard University, Washington, DC

POSITION

Artist

SELECTED COLLECTIONS

Columbia Presbyterian Hospital, New York, NY

World Federation of the United Nations, New York, NY

Manufacturers Hanover Trust Building, New York, NY

Atlanta Life Insurance Co., Atlanta, GA

SELECTED AWARDS

2003 Washington Post Arts Grant, Washington, DC

2002 Washington, DC Professional Development Grant

SELECTED EXHIBITIONS

2003 American Jazz Museum, Kansas City, MO

2001 *Threads of Freedom: The Underground Railroad Story in Quilts*, Firelands Association for the Visual Arts and Oberlin Historical and Improvement Organization, Oberlin, OH

 When the Spirit Moves: African American Dance in History and Art, Smithsonian Institution, Washington, DC

2000 *Blackness in Color*, Herbert F. Johnson Museum of Art, Cornell University, Ithaca, NY

1998 *Reflections of the Spirit*, Banneker-Douglass Museum, Annapolis, MD

 African American Quiltmakers, Banneker-Douglass Museum, Annapolis, MD

SELECTED REFERENCES

Brown, Kay, "The Emergence of Black Women Artists: The 1970s, New York," *The International Review of African American Art*, vol. 15, no. 1, 1998: 45.

Mazloomi, Carolyn, *Spirits of the Cloth: Contemporary African-American Quilts*, New York: Clarkson Potter Publishers, 1998: 39, 92–93, 97, 168, 178.

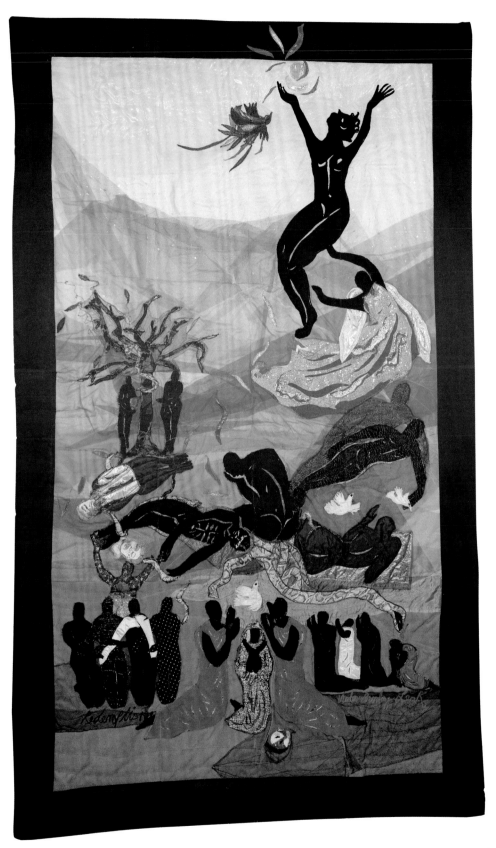

25 **THE REDEMPTION** *2003. 94 x 55 inches.*
Cotton, silk, tulle, metallic cloth; quilted.

Theresa Polley-Shellcroft

Turning upward is turning inward in meditation upon the fires of the Creator and the Creation. It is like being in the midst of a sacred fire that burns but does not consume. In this deep place, worlds upon worlds are born and reborn. It's like looking forward and looking backward, an experience that is placeless, timeless, ageless. It is a place of eternity, a glimpse into tomorrow and yesterday simultaneously.

DEUTERONOMY 4.35–36 *The LORD has shown you this, to prove to you that he alone is God and that there is no other. He let you hear his voice from heaven so that he could instruct you; and here on earth he let you see his holy fire, and he spoke to you from it.*

EDUCATION

1968 BS, Art Education, West Virginia State College, Institute, WV

1971 MA, Painting, Art History, Marshall University, Huntington, WV

1972–75 Graduate Studies, Art History, African American/African Art, University of Pittsburgh, Pittsburgh, PA

POSITION

Art History Instructor, Victor Valley Community College, Victorville, CA

Art Teacher, Mojave High School, Hesperia, CA

SELECTED AWARDS

2002 Who's Who Among American Teachers

Who's Who Among American Women

Artist in Residence, African Village Weekend, Pomona, CA

1998 Elementary Educator of the Year

SELECTED EXHIBITIONS

2003 *Sense of Fiber*, dA Center for the Arts, Pomona, CA

The Red Show, dA Center for the Arts, Pomona, CA

Our Vision … An Exhibition of African American Women Artists, The Gallery on 5th, San Bernadino, CA

Beyond the Mask, Pittsburgh Center for the Arts, National Juried Show, Pittsburgh, PA

Cuttress Gallery of Art, Pomona, CA

Finding Voice, Creating Vision, National Civil Rights Museum, Memphis, TN

African and African American Images in Art and Quilts, Victor Valley Community College, Victorville, CA (curator)

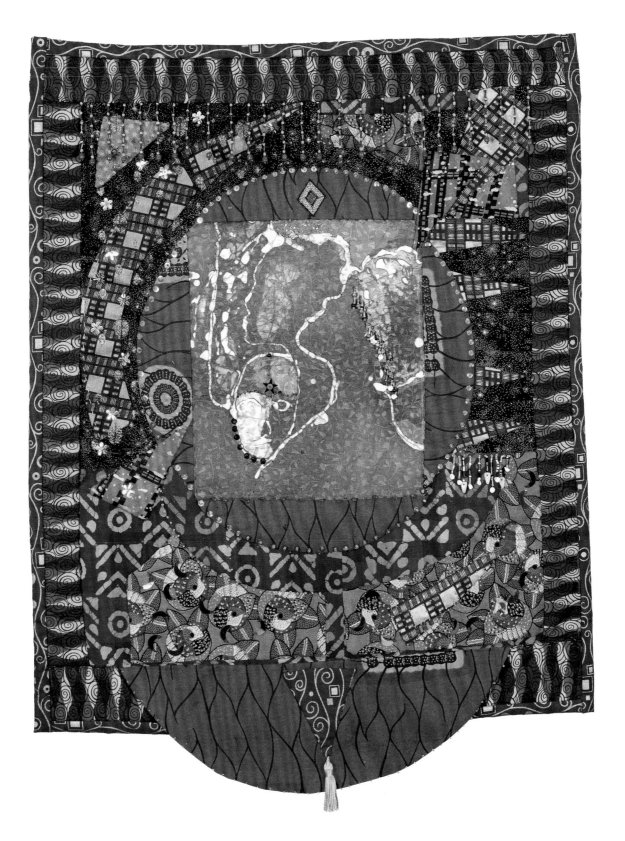

26 **LIFT UP THINE EYES UNTO HEAVEN**

2003. 29 x 22 inches. Cotton, beads, sequins; appliqué and hand quilted.

Tina Williams Brewer

This story quilt is layered in a complex rhythm of yesterday, today, and tomorrow. The concentration of the energy is an upward movement towards the circle of God's family. As I think of old-time religion, I see the red hands raised in respect and service to the Lord. Each person strives to embrace the light, support, and love of the Creator. This unique light provides an energy that keeps aglow the possibility of individual greatness in the eyes of God. The magnitude of the power moves us upward, penetrating the obstacles in our journey as we advance in our journey to hope and peace.

EDUCATION

1972 BA, Columbus College of Art and Design, Columbus, OH

POSITION

Rostered Artist, Pennsylvania Council for the Arts

Partnership with John M. Brewer, Trolley Station Oral History Center, Pittsburgh, PA

SELECTED COLLECTIONS

Pennsylvania State Museum, Harrisburg, PA

SELECTED AWARDS

2001 Pennsylvania Council for the Arts Fellowship

1997 Best in Show, Art of the State Exhibition, Harrisburg, PA

SELECTED EXHIBITIONS

2003 *Stop Asking, We Exist: Twenty African American Craftsmen*, United States Embassy, Accra, Ghana

2002 *African Inspirations*, Vector Valley Museum, Apple Valley, CA

 Patterns in Time: Quilt Making in America, Westmoreland Museum of American Art, Greensburg, PA

2001 *Spirits of the Cloth: Contemporary Quilts by African American Artists*, Florida Craftsmen, Inc., St. Petersburg, FL

 Africa: One Continent, Many Worlds, Carnegie Museum of Natural History, Pittsburgh, PA (guest artist)

SELECTED REFERENCES

"Ancient Symbols, New Meanings: A Modern Quilter Explores Age Old Images," *The Quilting Quarterly*, Spring, 2003: 18–20.

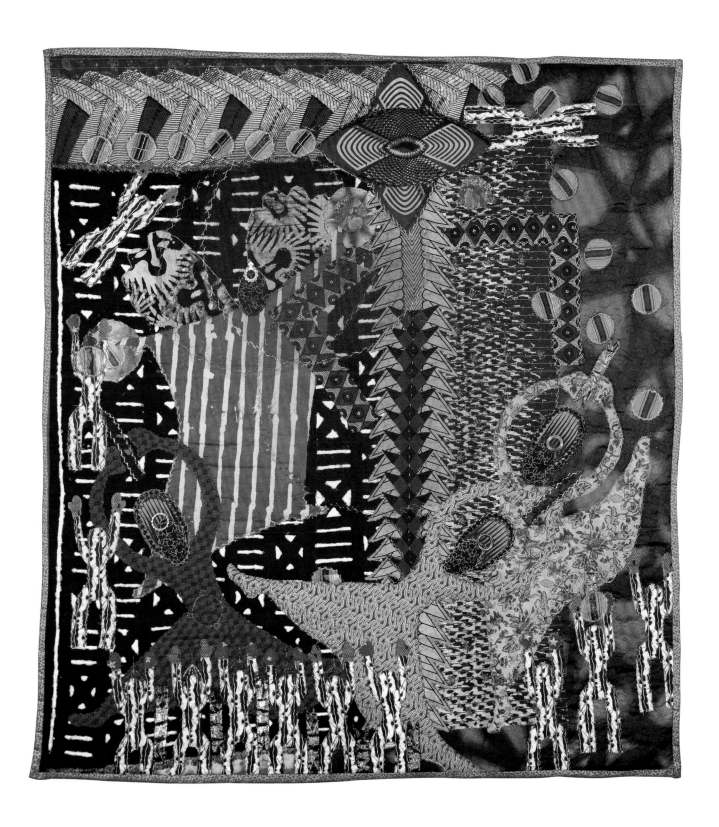

27 **THERE ARE NO MISTAKES** *1998. 53 x 48 inches.*
Cotton, silk; hand appliqué and quilted.

Adriene Cruz

As a child, I wanted to see and know everything –
without being seen. This piece was designed after
a flash of memory of being quite young comfortably
sitting on a closet shelf while peering through the
bamboo curtain hoping I would not be discovered.
Witness was inspired by that memory and became
a meditation on seeing and being seen. Feeling that
truly all that is in darkness does come into light,
the piece is about the presence of something greater
seeing all and the importance of correct action
and honesty.

EDUCATION

1975 BFA, School of Visual Arts, New York, NY

1991 Oregon School of Arts and Crafts,
 Portland, OR

POSITION
Artist

SELECTED COLLECTIONS
Schomburg Center for Research in Black Culture,
New York, NY

Hartsfield International Airport, Atlanta, GA

Harborview Medical Center, Seattle, WA

Portland Community College, Portland, OR

SELECTED AWARDS
Cultural Heritage Honor, Seattle, WA

Visual Arts Fellowship, Interstate Firehouse Cultural
Center, Portland, OR

Individual Artist Fellowship, Oregon Arts
Commission, Salem, OR

Lilla Jewel Award for Women Artists, McKenzie River
Gathering Foundation, Portland, OR

Bonnie Bronson Fellowship, Portland, OR

SELECTED EXHIBITIONS
1999 *Spirits of the Cloth: Contemporary Quilts by
 African American Artists*, American Craft
 Museum, New York, NY

SELECTED REFERENCES
Freeman, Roland L., *A Communion of the Spirits:
African-American Quilters, Preservers, and Their Stories*,
Nashville, TN: Rutledge Hill Press, 1996: 356–57.

Mazloomi, Carolyn, *Spirits of the Cloth: Contemporary
African-American Quilts*, New York: Clarkson
Potter/Publishers, 1998: 70–71, 74, 120–21, 152–53, 177.

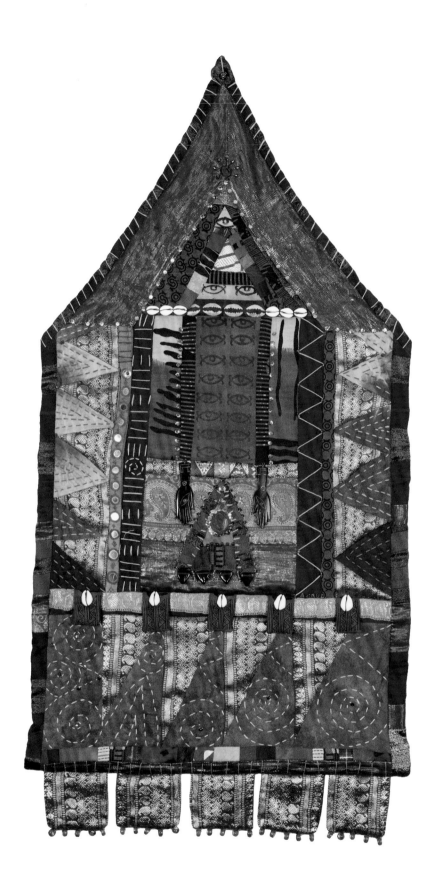

28 **WITNESS** *2001. 39 x 19 inches. Cotton and metallic fabrics, mirrors, cowrie shells, glass beads, crushed lavender.*

Yvonne Wells

This quilt was made to show that when you have faith in Jesus and follow Him, there is no turning back and His long arms will reach out and welcome you in. Faith is believing sight unseen.

EDUCATION
1964 BS, Stillman College, Tuscaloosa, AL
1975 MS, Alabama State University, Montgomery, AL

POSITION
Teacher, Tuscaloosa City School System (retired)

SELECTED COLLECTIONS
Birmingham Museum of Art, Birmingham, AL

International Quilt Study Center, University of Nebraska–Lincoln, Lincoln, NE

Collection of the Governor's Mansion, Montgomery, AL

SELECTED AWARDS
1999 Best of Show (Folk Art), Festival of Folk Life, Columbus, GA

1994–96, Best of Show, Kentuck Festival of the Arts,
1991 Northport, AL

SELECTED EXHIBITIONS
2002 *Quilts: Yvonne Wells, Celebrating Women's History Month*, Wynn Center, Stillman College Gallery of Art, Tuscaloosa, AL

2001 *Women Folk: Of Courage & Community*, Jeanine Taylor Folk Art Gallery, Winter Park, FL

1994 *Whose Broad Stripes and Bright Stars: Death, Reverence, and the Struggle for Equality in America*, Betty Rymer Gallery at The School of the Art Institute of Chicago, Chicago, IL

1989 *Stitching Memories: African-American Story Quilts*, Williams College, Williamstown, MA

SELECTED REFERENCES
Freeman, Roland L., *A Communion of the Spirits: African-American Quilters, Preservers, and Their Stories*, Nashville: Rutledge Hill Press, 1996: 190–94.

Kemp, Kathy, *Revelations: Alabama's Visionary Folk Artists*, Birmingham: Crane Hill Publishers, 1994: 208–11.

Lavitt, Wendy, *Contemporary Pictorial Quilts*, Layton, UT: Gibbs Smith, 1993.

Wahlman, Maude Southwell, *Signs and Symbols: African Images in African-American Quilts*, New York: Studio Books in association with Museum of American Folk Art, 1993.

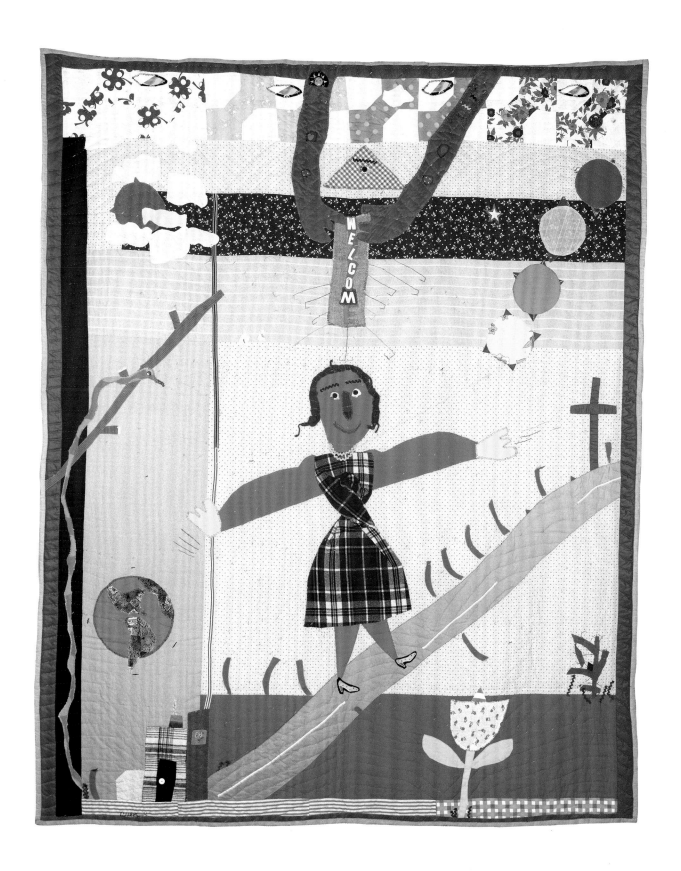

29 NO TURNING BACK *1995. 96 x 78 inches. Cotton;*
hand appliqué, hand quilted.

Yvonne Wells

In order for us to get to heaven we must use certain keys:

Key #1: Hunger. We must seek Him.

Key #2: Humility. We must humble ourselves to God.

Key #3: Holiness. We must turn from our wicked ways
and repent.

My quilt represents our duties to God. The green key in
the lower right hand corner symbolizes the ongoing need
to work as God wants us to in order to enter the Kingdom.

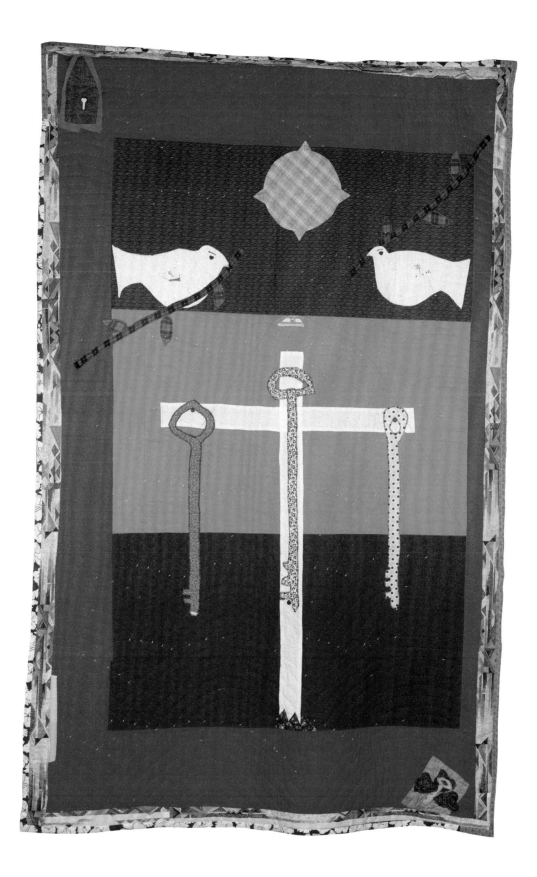

30 KEYS TO THE KINGDOM *2002. 98 x 62½ inches.*
Cotton, polyester; hand appliqué and quilted.

Kyra E. Hicks

In a recent Bible study class our assignment was to interpret the Lord's Prayer for ourselves. This quilt represents my attempt. In Matthew 6.9–13 Jesus instructs his followers on the model prayer. This prayer should acknowledge God's sovereignty and purpose in our lives. It should ask for a cleansing of sins so that God can hear our requests and intercessions for others. The Lord's Prayer has been the subject of historical quilts. In fact, at the 1895 Cotton States and International Exposition in Atlanta, Georgia, there was a Lord's Prayer quilt by an unknown quilter displayed in the Negro Building. A stereoview records the apparently appliquéd quilt protected in a glass case. In the same picture is Harriet Powers' famous *Bible Quilt*, now in the permanent collections of the Smithsonian Institution.

MATTHEW 6.9–13 *This, then, is how you should pray:*

"Our Father in heaven:
May your holy name be honored;
may your Kingdom come;
may your will be done on earth as it is in heaven.
Give us today the food we need.
Forgive us the wrongs we have done,
as we forgive the wrongs that others have done to us.
Do not bring us to hard testing,
But keep us safe from the Evil One.
For yours is the kingdom, and the power, and the glory forever. Amen."

EDUCATION

1986 BBA, Howard University, Washington, DC

1987 Diploma, London School of Economics, England

1991 MBA, University of Michigan, Ann Arbor, MI

SELECTED AWARDS

2000 Writing Grant, National Quilting Association, Inc.

SELECTED EXHIBITIONS

2002 *Six Continents of Quilts*, American Craft Museum, New York, NY (traveling)

2001 *Parallel Threads*, New England Quilt Museum, Lowell, MA

1999 *Spirits of the Cloth: Contemporary Quilts by African American Artists*, American Craft Museum, New York, NY (traveling)

1998 *Daughters of Harriet Powers*, Museum of African American Art, Tampa, FL

1996 *Spirit of the Cloth: African-American Story Quilts*, Wadsworth Atheneum, Hartford, CT

SELECTED REFERENCES

"Captured in Cloth," *American Legacy*, Spring 2000: 30–34.

"Daughters of Harriet Powers: A Tribute to an American Quiltmaker," *Patchwork Quilts Magazine*, October 1997: 15–20.

Freeman, Roland L., *A Communion of the Spirits: African American Quilters, Preservers, and Their Stories*, Nashville, TN: Rutledge Hill Press, 1996: 230–33.

Hicks, Kyra E., *Black Threads: An African American Quilting Sourcebook*, Jefferson, NC: McFarland & Co., 2003.

Mazloomi, Carolyn, *Spirits of the Cloth: Contemporary African-American Quilts*, New York: Clarkson Potter/Publishers, Inc., 1998: 95, 135, 156, 182.

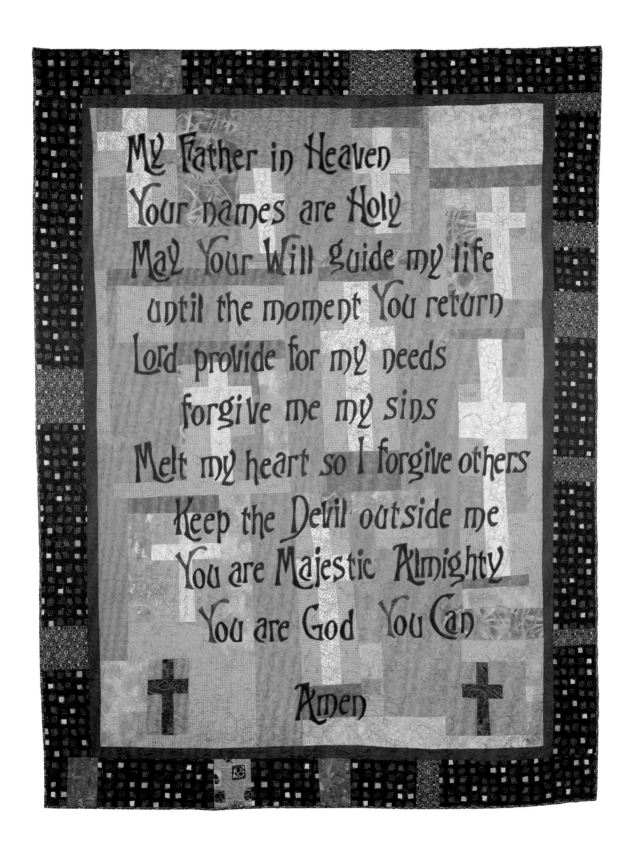

31 **THE LORD'S PRAYER QUILT** *2003. 96 x 75 inches.*
Cotton; machine appliqué, machine quilted.

Kyra E. Hicks

This quilt includes 112 different packets with an individual personal prayer or dream enclosed within. This quilt was stitched to help recall past aspirations at a low point in my life. I slept under this quilt for several weeks and soon my life situation started to change. I was offered a job in a new city and state.

32 **PRAYERS AND DREAMS** *1998. 84 x 62 inches.*
Cotton; machine appliqué and quilted.

Zene Peer

This piece was a three-year labor of love and necessity. I needed a place to be with God during times when the stress of mortal existence overwhelmed me. Family, friends, school, work, and the Devil interfered with my peace of mind. Through God's grace, I was gifted with a vision to create *Prayer Closet*. The imagery may not be unique, but the symbolism is crystal clear.

EDUCATION

2000 BA, University of Wisconsin, Milwaukee, WI

2002 Teaching Certification

POSITION

Middle School Teacher, Milwaukee, WI

SELECTED AWARDS

2002 Compton Fellowship, Americorp

1993 Master Artist Recognition, Inner Arts Council Art Festival, Milwaukee, WI

 First Place Overall Artists Purchase Award, Inner City Arts Council, Milwaukee, WI

SELECTED COLLECTIONS

Inner City Arts Council, Milwaukee, WI

SELECTED EXHIBITIONS

2003 *JUJU*, Milwaukee Institute of Art & Design, Milwaukee, WI

2002 *Tamka*, Union Gallery, University of Wisconsin, Milwaukee, WI

1998 *Facsimile*, Chicago Textile Center, Chicago, IL

 External Traditions, Charles Allis Art Museum, Milwaukee, WI

SELECTED REFERENCES

Chickering, Pam, "African American Quilters," *Oconomowoc Time Out Newspaper*, May 1999: 9.

Jackson, Sandra, "The Fabric of Our Culture," *Black Issues Book Review Magazine*, May-June 1999: 35–38.

Krause, Joy, "Spirits of the Cloth," *Milwaukee Journal Sentinel, Interiors Magazine*, March 1999: 4–5, 18.

Mazloomi, Carolyn, *Spirits of the Cloth: Contemporary African-American Quilts*, New York: Clarkson Potter/Publishers, 1998: 20, 26, 93, 100, 186.

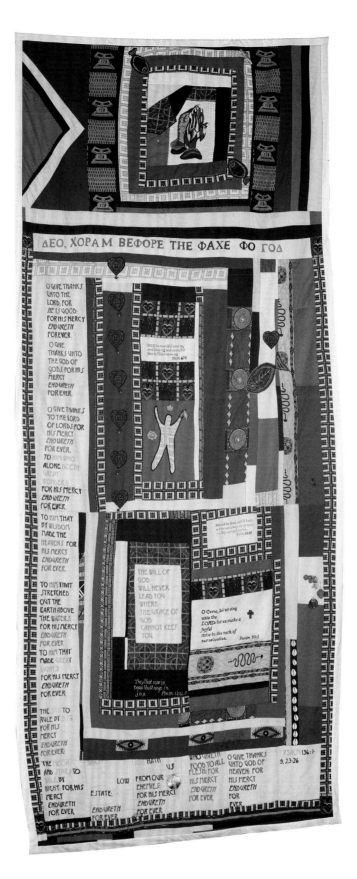

33 PRAYER CLOSET *1999. 112 x 47 inches. Cotton, metal, glass, bone, shell beads; hand embroidery, quilted.*

Ed Johnetta Miller

I went to the intensive care unit to visit my dad after he had undergone a fifteen-hour operation. He opened his eyes and told me that I looked like a blurry healing spirit floating in the sky. He smiled and he began to repeat over and over again Psalm 27: "The Lord is my light and my salvation – whom shall I fear? The Lord is the stronghold of my life." Dad is such a believer in the healing power of Prayer. This quilt is in honor of my father and in strong belief in the will of God.

PSALM 27.1–3

The LORD is my light and my salvation;
* I will fear no one.*
The LORD protects me from all danger;
* I will never be afraid.*

When evil people attack me and try to kill me,
* they stumble and fall.*
Even if a whole army surrounds me,
* I will not be afraid;*
even if enemies attack me,
* I will still trust God.*

EDUCATION

1982 MA, Education Center for Human Development, Hartford Seminary Campus, Hartford, CT

Bryant College, Providence, RI

POSITION

Executive Director, OPUS Intergenerational Program, Hartford, CT

Co-Founder, Hartford Artisans' Center, Hartford, CT

Master Teaching Artist, State of Connecticut

SELECTED COLLECTIONS

Wadsworth Atheneum, Hartford, CT

Renwick Gallery, American Art Museum, Smithsonian Institution, Washington, DC

Nelson Mandela's National Museum, Capetown, South Africa

SELECTED AWARDS

2003 State of Connecticut Governor's Art Award

President's Award, Amistad Foundation, Wadsworth Atheneum, Hartford, CT

2002 The Ivy Education Award

SELECTED EXHIBITIONS

2003 *Diversity of the Cloth*, Portfolio, St. Louis, MO

1999 *Spirits of the Cloth: Contemporary Quilts by African American Artists*, American Craft Museum, New York, NY (traveling)

1998 *In the Spirit of the Cloth*, Museum of Fine Art, Spelman College, Atlanta, GA

1997 *Daughters of Harriet Powers,* Museum of African American Art, Tampa, FL

1993 *Uncommon Beauty in Common Objects: The Legacy of African-American Craft Art*, National Afro-American Museum and Cultural Center, Wilberforce, OH (traveling)

SELECTED REFERENCES

Freeman, Roland L., *A Communion of the Spirits: African-American Quilters, Preservers, and Their Stories*, Nashville: Rutledge Hill Press, 1996: 281, 283–84.

Mazloomi, Carolyn, *Spirits of the Cloth: Contemporary African-American Quilts*, New York: Clarkson Potter/Publishers, 1998: 13, 24–27, 185.

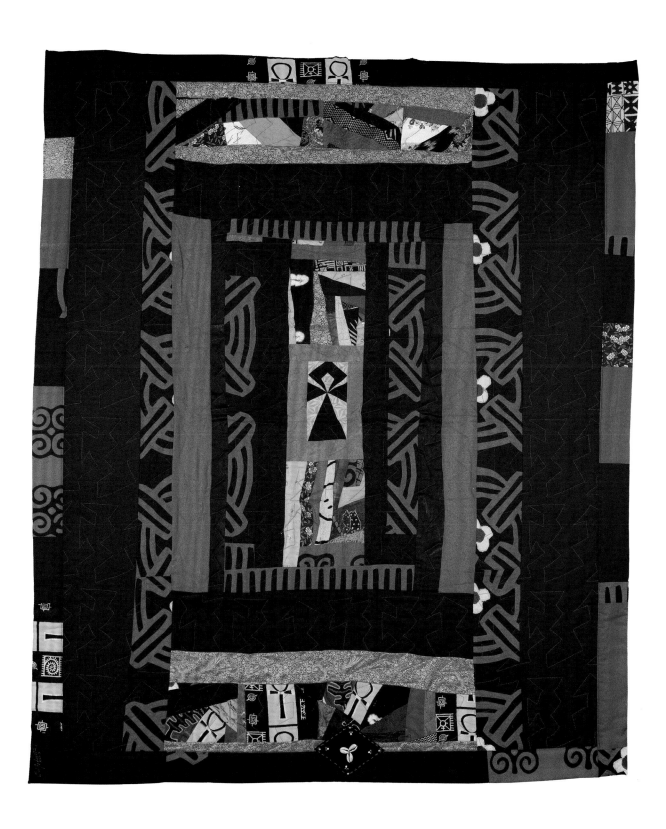

34 HEALING SPIRIT II *2003. 51 x 43 inches. Cotton; machine pieced and quilted.*

Cynthia H. Catlin

This quilted fiber art was designed to value the freedom to approach God in the spirit. God is my source of joy and I praise him every day. Each day I continue to thank God for his favor, his mercy, and his grace. It is an honor to reach out and touch his hand and to connect as we pray in the spirit and travel from darkness into the light and the truth. Jesus is the vine of life and we are the branches. As we continue to pray and seek guidance we continue to connect and we are touched by the Holy Spirit, represented by the dove. When I combine my love of needlework with prayer, I understand God's love for us and how he stitches the fabric of our lives with His master plan. I will continue to be an instrument of God and his work of art. My favorite scriptures (Psalms 9.1, 143.6, 143.10, and Proverbs 3.5) are stitched in the borders of this fiber art.

PSALM 9.1 *I will praise you, LORD, with all my heart;*
I will tell of all the wonderful things you have done.

PSALM 143.6 *I lift up my hands to you in prayer;*
like dry ground my soul is thirsty for you.

PSALM 143.10 *You are my God; teach me to do your will.*
Be good to me, and guide me on a safe path.

PROVERBS 3.5 *Trust in the LORD with all your heart. Never rely*
on what you think you know.

EDUCATION
1979 BA, University of Toledo, Toledo, OH

POSITION
Quilt Artist

SELECTED EXHIBITIONS
South Bay Quilters Guild Show, Torrance Cultural Arts Center, Torrance, CA
Uhuru Guild Show, Fairfield Inn, Beltsville, MD
Threads Unraveled-Stories Revealed, New York, NY
Mayor's Office Art Gallery, Denver, CO (curator)
Koelbel Library Art Gallery, Englewood, CO (curator)
Rocky Mountain Quilt Museum, Golden, CO
National Headquarters of the National Council of Negro Women, Washington, DC
Charles Sumner School Museum and Archives, Washington, DC

SELECTED REFERENCES
Mazloomi, Carolyn, *Spirits of the Cloth: Contemporary African-American Quilts*, New York: Clarkson Potter/Publishers, 1998: 32–33, 178.
Walner, Hari, *Exploring Machine Trapunto: New Dimensions*, Lafayette, CA: C & T Pub., 1999.

35 PRAY IN THE SPIRIT *2003. 41 x 53 inches.*
Cotton and metallic fabrics, cotton, rayon, and metallic
threads, beads; machine pieced and quilted.

Sandy Benjamin-Hannibal

I always feel protected, watched over, and guided, in thought and action, to do the right thing. I always feel cared for, that I can do. I feel sponsored. I feel the closeness of the Creator, of my guardian angels, and that I have my ancestors with me at all times. I grew up in the Bible Belt, in a Christian environment of family and the Presbyterian Church. My education through eighth grade was at a parochial school. The first three semesters of my college studies were at a Presbyterian school.

This quilt is a visualization of that place where my spirit is at peace and my character and being are at their best. Expression through quiltmaking is one of my gifted abilities. As is my custom, the work did not acquire a name until it was nearly completed. My spirit is housed within my body and my total being is at peace in this beautiful garden that is my past, my present, and my future, extending into infinity. The Lord is my shepherd. He does guide me. He does lead me. He does restore my soul. I am grateful for his presence. I do believe that all things are possible through faith.

In *He Restoreth My Soul* I use the technique of stained glass patchwork appliqué. This very labor-intensive method engages my mind and proves a pleasing and relaxing experience for me. To create this work I first visualized the kind of place and thoughts that put my mind, body, and spirit at ease and in comfort. I had to

EDUCATION
Mary Holmes College, West Point, MS
Pratt Institute, Brooklyn, NY
Fashion Institute of Technology, New York, NY

POSITION
Artist
Founder, Eskae.Bee Wear
President, Ebony Quilters of Southeast Queens, Inc.

SELECTED COLLECTIONS
Local 1199 Training and Upgrading Fund,
New York, NY
Newark Museum, Newark, NJ

SELECTED AWARDS
1997 Ribbon Winner, Vermont Quilt Festival

SELECTED EXHIBITIONS
2003 *Quilt Masterpieces: From Folk Art to Fine Art*,
 Newark Museum, Newark, NJ

2002 *Honoring the Tradition*, Johnson-
 Humrickhouse Museum, Roscoe Village,
 Coschocton, OH

2001 *A Flowering of Their Souls*, The Black Academy
 of Arts and Letters, Dallas, TX

2000 *Roots of Racism*, Fall 2000, Vertigo Studios,
 Memphis, TN

1999 *Spirits of the Cloth: Contemporary Quilts by
 African American Artists*, American Craft
 Museum, New York, NY (traveling)

 African-Americans and the Bible, Union
 Theological Seminary, New York, NY

1998 *In the Spirit of the Cloth: Contemporary
 African-American Quilters*, Museum of Fine
 Art, Spelman College, Atlanta, GA

1996 *A Tribute to Harriet Powers*, Countee Cullen
 Library, New York, NY (curator)

SELECTED REFERENCES
Hicks, Kyra E., *Black Threads: An African American Quilting Sourcebook*, Jefferson, NC: McFarland & Co., 2003.

Mazloomi, Carolyn, *Spirits of the Cloth: Contemporary African-American Quilts*, New York: Clarkson Potter/Publishers, 1998: 34, 63, 176.

36 **HE RESTORETH MY SOUL** *2003.*
57⅛ x 74⅜ inches.

take my mind to a very quiet place to meditate and to think. Meditation opened my mind, enabling thoughts and pencil lines to flow freely, and me to step out on faith. As Psalm 23 states, "He leadeth me beside still waters."

PSALM 23

The LORD is my shepherd;
 I have everything I need.
He lets me rest in fields of green grass
 and leads me to quiet pools of fresh water.
He gives me new strength.
He guides me in the right paths, as he has promised.
Even if I go through the deepest darkness,
 I will not be afraid, LORD,
 for you are with me.
Your shepherd's rod and staff protect me.

You prepare a banquet for me,
 where all my enemies can see me;
you welcome me as an honored guest
 and fill my cup to the brim.
I know that your goodness and love will be with me all my life;
 and your house will be my home as long as I live.

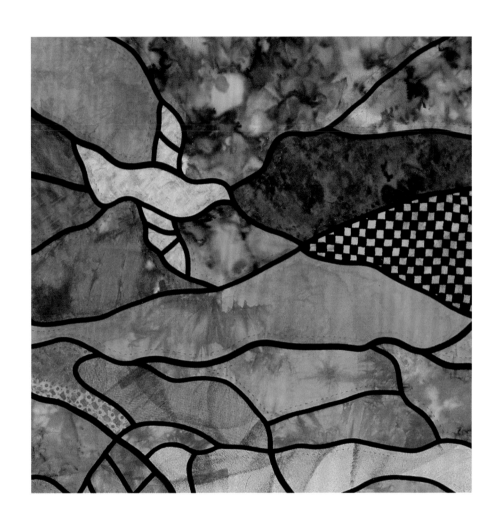

Blessed Are the Piece Makers

Myrah Brown Green

One of my earliest memories of being exposed to Christianity was the singing of the song "At the Cross." I grew up in a Baptist church. Our minister was well over 70 by the time I was 10. Every time we sang this hymn the pianist played in an upbeat tempo. All of the young people in the church really enjoyed participating in this meditation, hence we memorized the words and the cross became our first symbol of faith.

AT THE CROSS (refrain)

At the cross, at the cross where I first saw the light,
And the burden of my heart rolled away, rolled away,
It was there by faith I received my sight,
And now I am happy all the day!

EDUCATION

1974–76 Boston University, Boston, MA

1979 BFA, Pratt Institute, Brooklyn, NY

2004 PhD, The Union Institute and University, Cincinnati, OH

POSITION

1980 to present, Co-Founder/Program Coordinator, Crown Heights Youth Collective, Inc., Brooklyn, NY

1991 to present, Founder/Principal, Collective Fellowship and Peace Academy, New York, NY

SELECTED COLLECTIONS
Satta Gallery, Brooklyn, NY

Crown Heights Youth Collective, Brooklyn, NY

SELECTED AWARDS

2002 Key to the City of Cambridge, MA

2000 Third Place, Vertigo Studios, Memphis, TN

SELECTED EXHIBITIONS

2003 *I Remember Mama: The Hand that Rocks the Cradle*, Quilt, Inc., Houston, TX

2002 *Finding Voice, Creating Vision*, National Civil Rights Museum, Memphis, TN

 Stitching Justice: Unlocking Our Hearts, Minds and Souls, The Nathan Cummings Foundation, New York, NY

2001 *Threads of Freedom: The Underground Railroad Story in Quilts*, Firelands Association for the Visual Arts, and Oberlin Historical and Improvement Organization, Oberlin, OH

 Six Continents of Quilts, The American Craft Museum, New York, NY

2000 *Roots of Racism: Ignorance and Fear*, Vertigo Studios, Memphis, TN

1999 *Spirits of the Cloth: Contemporary Quilts by African American Artists*, The American Craft Museum, New York, NY (traveling)

SELECTED REFERENCES
Mazloomi, Carolyn, *Spirits of the Cloth, Contemporary African-American Quilts*, New York: Clarkson Potter/Publishers, 1998: 37, 177.

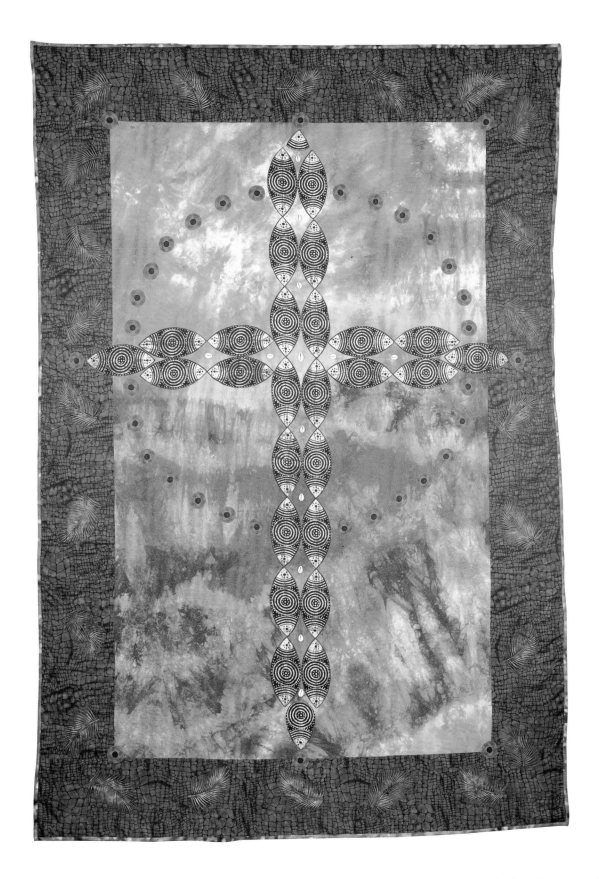

37 **AT THE CROSS** *2003. 86 x 59 inches. Cotton; machine appliqué and quilted.*

Trish Williams

This piece was inspired by my love for dance and how, as a child, I saw dance performed in the Missionary Baptist Church services I attended. As I became older I learned that dance is part of many religious and cultural ceremonies as a form of worship. The purple used in the quilt represents the highest form of spirituality and the red represents the "blood of life" that flows through us all. The Adrinka symbol, Gye Nyame, on the middle figure signifies the omnipotence of God. This great panorama of creation dates back to time immemorial. No one lives who saw its beginning and no one will live to see its end, except God. This symbol comes from Ghana and the Ivory Coast. The white hankies were always a part of these dance rituals and I often wonder why they were used. Are the dancers fanning the flame of the Spirit?

SELECTED AWARDS

1999 Purchase Award, Du Sable Museum Art Fair, Chicago, IL

SELECTED EXHIBITIONS

2003 *Sacred Threads*, Reynoldsburg, OH

Behind the Lions Day: Sing Me a Story – A Marshall Field's Family Festival, The Art Institute of Chicago, Chicago, IL

2002 Bethel Cultural Arts Center, Chicago, IL (solo)

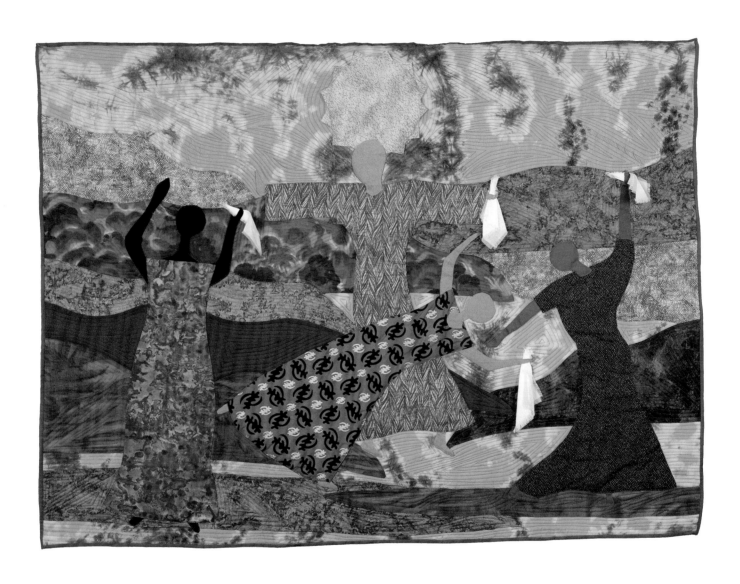

38 **DANCE OF PRAISE** *2002. 42 x 56 inches. Cotton; appliqué, hand and machine quilted.*

Cynthia Lockhart

This quilt is about the joy I feel when I sing the praises unto the Lord. Music is depicted as colorful and full of rhythms with a multiplicity of vibrations. When I sing and shout the praises I have a spiritual connection with the Lord; it makes me feel happy. The title and subject are taken from Psalm 98.4.

PSALM 98.4 *Sing for joy to the LORD, all the earth; praise him with songs and shouts of joy!*

EDUCATION

1975 BS, University of Cincinnati, Cincinnati, OH

1976 Fashion Institute of Technology, New York, NY

1996 Summer Symposium, Domus Academy, Milan, Italy

1999 MA, University of Cincinnati, Cincinnati, OH

POSITION

Professor, Division of Professional Practice, University of Cincinnati, Cincinnati, OH

SELECTED AWARDS

2000–03 Arts Competitive Awards, Arts Consortium, Cincinnati, OH

2002 Artist Merit Award, *Black Creativity,* Museum of Science and Industry, Chicago, IL

1985 Key to the City of Cincinnati, Outstanding Achievement in Fashion Design

SELECTED EXHIBITIONS

2003 *30 Year Reunion Show,* Arts Consortium, Cincinnati, OH

 Life in Times of Education, STRS, Columbus, OH

2002 *The Art Is in the Bag: Contemporary Handbags by Master Craftsmen,* Ohio Craft Museum, Columbus, OH

2000 *Visualize This,* Arts Consortium, Cincinnati, OH

SELECTED REFERENCES

Stein, Jerry, "Reunion Show a Who's Who of Local Artists," *The Cincinnati Post,* January 27, 2003.

Ybern, Martha, "Professor Cynthia Lockhart Honored with National Award," *University of Cincinnati News,* January, 29, 2001.

39 **MAKE A JOYFUL NOISE UNTO THE LORD**

2002. 42 x 30 inches. Cotton, silk, beads, acrylic paint; machine appliqué and quilted.

Dindga McCannon

This is a sort of portrait of two women friends of mine who are ministers. I always knew they were ministers but really saw them as such when one day I saw them dressed for a prayer meeting. What a difference! They seemed full of peace, very wise, and very naturally on a mission for God. I don't remember seeing women of the cloth when I went to church as a young person. I think this image is just another picture of how some things have changed and how in today's world women have so many more options.

POSITION
Artist

SELECTED COLLECTIONS
The Studio Museum in Harlem, New York, NY
Schomburg Center for Research in Black Culture, New York, NY

SELECTED AWARDS
2001 Stitch in Time, Judges Choice, Wearable Art, International Quilt Association, Houston, TX

SELECTED EXHIBITIONS
1999 *Spirits of the Cloth: Contemporary Quilts by African American Artists*, American Craft Museum, New York, NY (traveling)

1998 *Black Creativity Prism*, Museum of Science and Industry, Chicago, IL

1997 *Visions Speaking to the Soul*, Schomburg Center for Research in Black Culture, New York, NY

1993 *Uncommon Beauty in Common Objects: The Legacy of African-American Craft Art*, National Afro-American Museum and Cultural Center, Wilberforce, OH

SELECTED REFERENCES
Mazloomi, Carolyn, *Spirits of the Cloth: Contemporary African-American Quilts*, New York: Clarkson Potter/Publishers, 1998: 23, 60–61, 185.

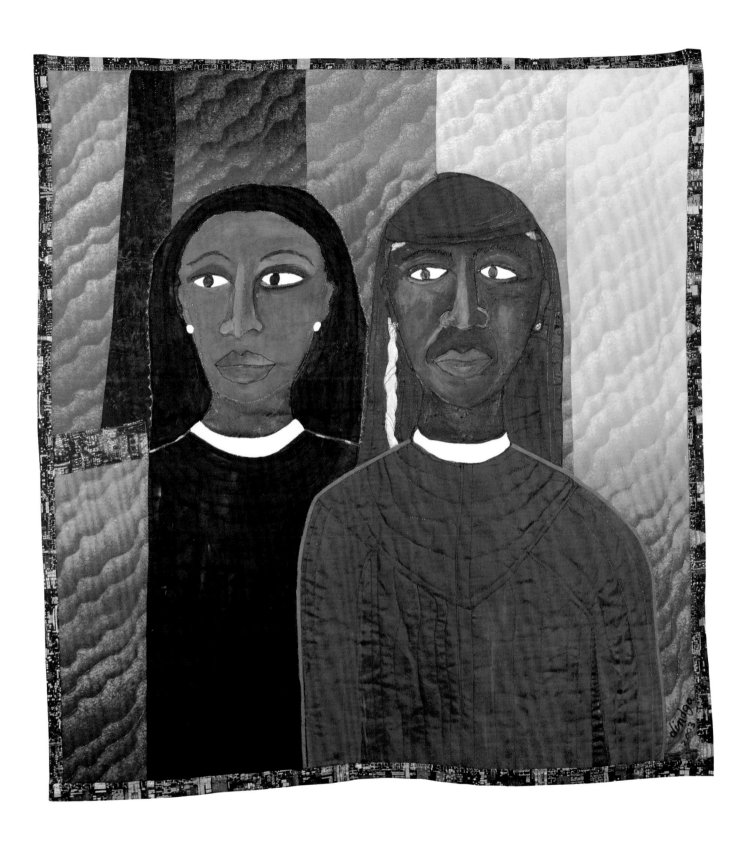

40 **TWO MINISTERS** *2003. 43 x 41 inches. Cotton, acrylic paint; machine quilted.*

Cleota Proctor Wilbekin

Rev. Milton Berner, pastor at Immanuel Lutheran Church, where I am a member, will wear this communion chasuble. A necessary aspect of Christian religion is communion, the asking for forgiveness of sins through His body, the bread, and the wine. The lacework in the chasuble belongs to four generations of women in my family: great-grandmother Julia Baker Proctor from Missouri; grandmother Maude Smith Proctor from Iowa; mother Julia M. Proctor from Ohio; mother-in-law Elizabeth Barry Wilbekin from St. Croix, Virgin Islands; and pieces from my wedding gown.

EDUCATION
BA, Drake University, Des Moines, IA
MA, Iowa University, Iowa City, IA
PhD, Columbia University, New York, NY
LLB, Northwestern University, Chicago, IL

SELECTED COLLECTIONS
Urban League of Greater Cincinnati, Cincinnati, OH
Arts Consortium, Cincinnati, OH

SELECTED AWARDS

1990, 1989, 1986	President's Award, National Bar Association
1989, 1988, 1982	Woman of the Year, Cincinnati Chapter of the Friends of Amistad
1984	Honorary Citizen, City of New Orleans

SELECTED EXHIBITIONS

1999	The Grailville, Loveland, OH
	Miami University, Oxford, OH

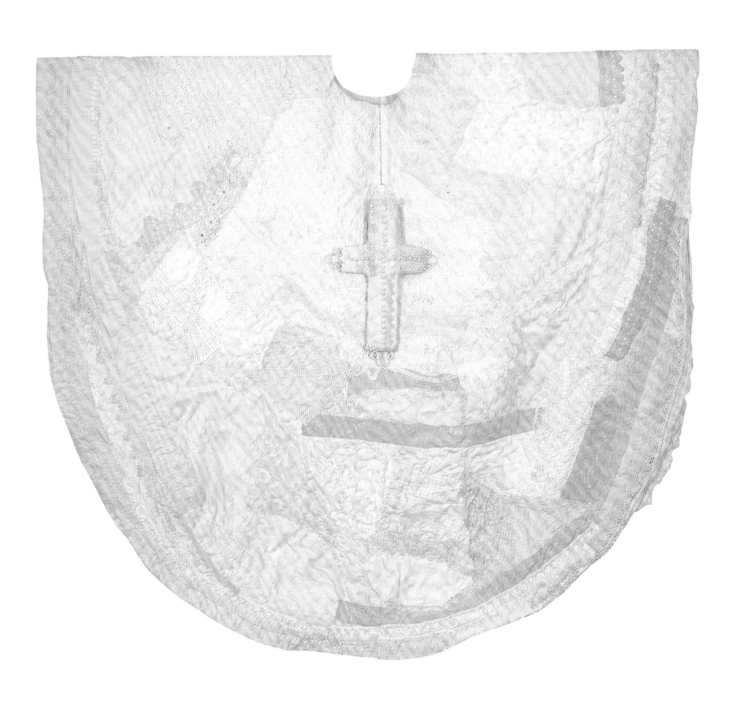

41 COMMUNION ROBE AND CROSS *2003.*
49 x 56 inches. Cotton, lace.

Michael Cummings

The theme for my quilt was developed after I attended the Morehouse Glee Club's concert at Abyssinian Baptist Church in 1993. While sitting with friends and other church members a friend whispered to me that the song currently being performed would make an interesting quilt theme. I listened more intently to the words and agreed that it would be an interesting story to translate into a quilt.

I first had to reflect on what images I wanted in the quilt. Immediately I saw my African American community under attack: AIDS, guns, crime, and racism killing my brothers and sisters while mothers and fathers mourn the loss of their children. In the quilt's composition the house of the Lord is outlined in white with a cross at its peak. A man of God is holding a cross while standing inside a church. The cross itself is decorated with antique buttons sewn over the cross design. The male form on the cross represents the unjust suffering and death of our black brothers. The deer represents the disbeliever and the serpent represents the temptation in the garden. The rose pattern fabric represents the sweetness, joy, and love found in the kingdom.

EDUCATION
1974 Art Students' League, New York, NY
1980 BA, State University of New York, NY

POSITION
New York State Council on the Arts Associate,
New York, NY

SELECTED COLLECTIONS
Smithsonian Institution, Renwick Gallery,
Washington, DC
Bill and Camille Cosby, New York, NY
Alonzo and Tracy Mourning, Miami, FL
Whoopie Goldberg, Los Angeles, CA
American Craft Museum, New York, NY
The Studio Museum in Harlem, New York, NY

SELECTED AWARDS
2003 National Underground Railroad Freedom
 Center, Cincinnati, Ohio (commission)
2001 Louis Comfort Tiffany Biennial Award, Louis
 Comfort Tiffany Foundation, Oyster Bay, NY
 Children's Book of Distinction, Riverbank
 Review, Minneapolis, MN
2000 Excellence in Design Award, City of New York
 Art Commission, New York, NY

SELECTED EXHIBITIONS
2001 New England Quilt Museum, Lowell, MA
2000 European Quilt Expo VII, Strasbourg, France
1997 Cincinnati Art Museum, Cincinnati, OH
1981 Yale University, New Haven, CT

SELECTED REFERENCES
Mazloomi, Carolyn, *Spirits of the Cloth: Contemporary African-American Quilts*, New York: Clarkson Potter/Publishers, 1998: 84, 140, 180.

Shaw, Robert, *The Art Quilt* [New York]: Hugh Lauter Levin Associates, 1997.

Tobin, Jacqueline L. and Raymond G. Dobard, *Hidden in Plain View: The Hidden Story of Quilts and the Underground Railroad*, New York: Doubleday, 2000.

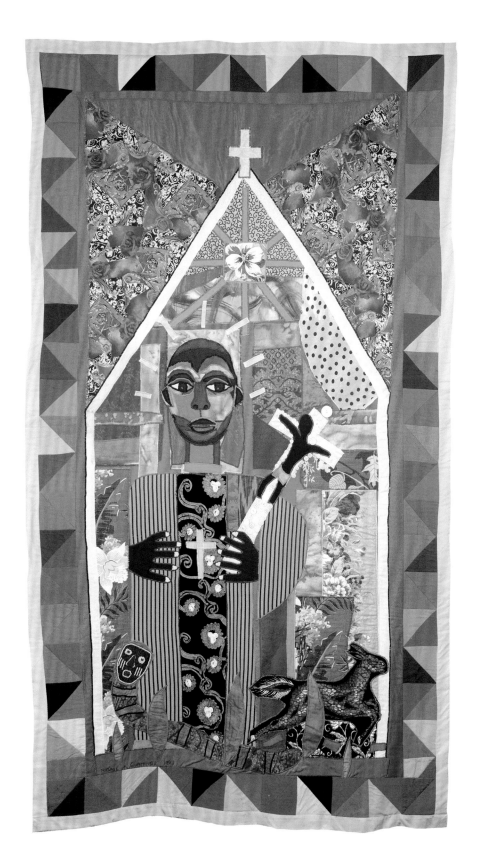

42 **TAKE MY BROTHER HOME** *1999. 92 x 52 inches.*
Cotton, acrylic paint; machine appliqué, machine quilted.

Phyllis Stephens

A songwriter indicates that the Lord will lay himself down like a bridge over troubled waters in the time of adversity. Jehovah-Shalom-Giver of Peace (Judges 6.24). God always gives a way of escape. Often we choose our path, but his way is perfect.

JUDGES 6.24 *Gideon built an altar to the* LORD *there and named it "The Lord is Peace." (It is still standing at Ophrah, which belongs to the clan of Abiezer.)*

PROVERBS 3.5–6 *Trust in the* LORD *with all your heart. Never rely on what you think you know. Remember the* LORD *in everything you do, and he will show you the right way.*

1 PETER 5.7 *Leave all your worries with him, because he cares for you.*

EDUCATION
Boston University, Boston, MA

POSITION
Artist

SELECTED COLLECTIONS
The Women's Medical Center, Kennesaw, GA

Black Enterprise, New York, NY

Girls, Inc., Smyrna, GA

SELECTED AWARDS
2001 Georgia Council for the Arts Advisory Award

1998 National Association of 100 Black Women, Artist of the Year

American Story Quilt Achievement Award

SELECTED EXHIBITIONS
2002 Chattanooga African-American Museum, Chattanooga, TN

2000 The Nyumburu Black History Museum, Silver Spring, MD

1999 The Renaissance Center, Dickson, TN

1998 The APEX Museum, Atlanta, GA

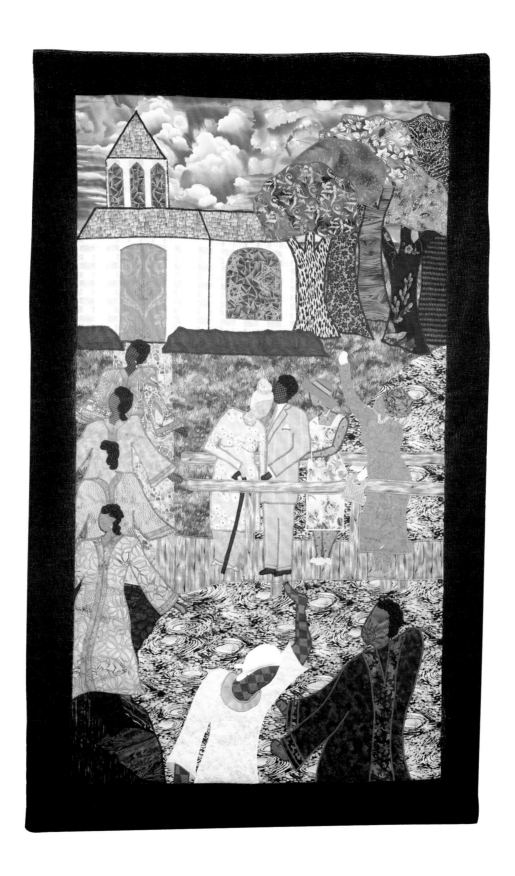

43 BRIDGE OVER TROUBLED WATERS *2002.*
72 x 44 inches. Cotton; appliqué, quilted.

We Have Come This Far by Faith

Gwendolyn Magee

The quilts, *Bitter the Chastening Rod* and *Our New Day Begun*, are part of a series that is based on the song "Lift Every Voice and Sing," by James Weldon Johnson, which most of us know as "the Negro National Anthem." The scope of this project has become my own personal journey of the spirit and has been a fulcrum for my true artistic awakening. It has become a direct connection with something greater than myself and has immersed me deep into introspection as I examine my cultural heritage as an African American.

For many of us, the song "Lift Every Voice and Sing" has a strong emotional pull, particularly for those of us who are over 50 and who grew up in southern towns with Jim Crow laws and segregated school systems. For us it was sung at every school assembly, if not at the start of every school day. It was sung at some point during almost every community program or event, whether it occurred in church, in a school auditorium, in the Masonic Lodge, or at the YM or YWCA. The anthem was, and still is, synonymous with pride in self, with pride in heritage, with pride in community, and with the belief that we can overcome – whether we are talking about overcoming racism, or segregation, or hatred, or oppression, or Jim Crow, or inequality, or injustice, or intolerance, or unemployment, or second-class schools, or second class citizenship, or police brutality, or being "arrested while black," or whatever. The silhouetted figure is a chained pregnant woman who is being cruelly whipped. This particular imagery

EDUCATION
1963 BA, Woman's College of the University of North Carolina, Greensboro, NC

POSITION
Vice President, Business Development, Minack Inc., Jackson, MI

SELECTED COLLECTIONS
Renwick Gallery, American Art Museum, Smithsonian Institution, Washington, DC

SELECTED AWARDS
2003 Visual Artist of the Year, Mississippi Institute of Arts and Letters Award

Nominee, Governor's Award for Excellence in the Arts

SELECTED EXHIBITIONS
2002 *Finding Voice*, National Civil Rights Museum, Memphis, TN

Apex Museum, Blaffer Gallery, University of Houston, Houston, TX

2001 *Testimony Throughout*, National Art Gallery of Namibia, Namibia, Africa

1999 *Spirits of the Cloth: Contemporary Quilts by African American Artists*, American Craft Museum, New York, NY (traveling)

1998 Cosby Museum of Fine Art, Spelman College, Atlanta, GA

SELECTED REFERENCES
Dugan, Eleanor, "The Power Series: Gwen Magee Finds Inspiration in an Anthem," *Quilting Quarterly: Journal of the National Quilting Association*, Fall 2001: 8–10.

Freeman Roland L., *A Communion of the Spirits: African-American Quilters, Preservers, and Their Stories*, Nashville, TN: Rutledge Hill Press, 1996: 372, 374.

Hicks, Kyra E., *Black Threads: An African American Quilting Sourcebook*, Jefferson, NC: McFarland & Co., 2003: 157, 224, E (photograph).

Johnson, Mary Elizabeth, *Mississippi Quilts*, Jackson, MS: Mississippi Quilt Association, University of Mississippi Press, 2001: 195–96.

Mazloomi, Carolyn, *Spirits of the Cloth: Contemporary African-American Quilts*, New York: Clarkson Potter/Publishers, 1998: 128–29, 167, 170, 184.

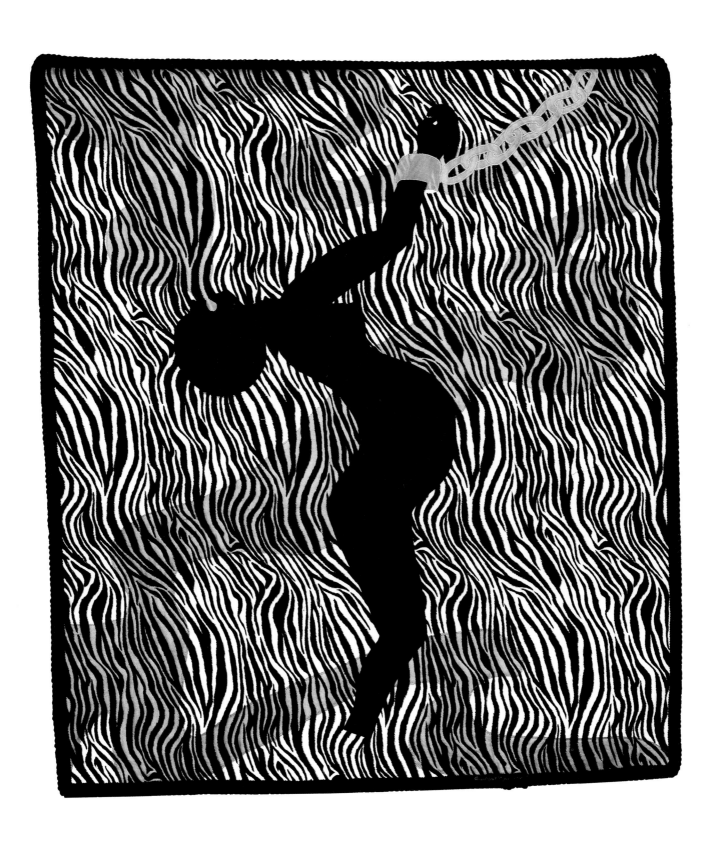

44 BITTER THE CHASTENING ROD *2000.*
44 x 38 inches. Machine appliqué and quilted.

is used to illustrate how slaves were often dehumanized, and were treated far worse than any piece of livestock. But it wasn't until the visual representation of her screaming in agony was added did the quilt finally attain the full emotional impact I was trying to capture. However, the screams, which start at the mouth and wrap around her body, most often are perceived by viewers as being a visual representaton of assaults on the woman's soul. They see it as slavery literally ripping her soul from her body and that interpretation seems even more "right" to me. This is truly an example of how viewers are sometimes more perceptive than the artist is about what is being depicted.

LIFT EVERY VOICE AND SING

Lift every voice and sing
Till earth and heaven ring,
Ring with the harmonies of liberty;
Let our rejoicing rise
High as the listening skies,
Let it resound loud as the rolling sea.
Sing a song full of the faith that the dark past has taught us,
Sing a song full of the hope that the present has brought us;
Facing the rising sun of our new day begun,
Let us march on till victory is won.

Stony the road we trod,
Bitter the chastening rod,
Felt in the days when hope unborn had died;
Yet with a steady beat,
Have not our weary feet
Come to the place for which our fathers sighed?
We have come over a way that with tears has been watered,
We have come, treading our path through the blood of the slaughtered;
Out from the gloomy past,
Till now we stand at last
Where the white gleam of our bright star is cast.

God of our weary years,
God of our silent tears,
Thou who hast brought us thus far on the way;
Thou who hast by Thy might
Led us into the light,
Keep us forever in the path, we pray.
Lest our feet stray from the places, our God, where we met Thee.
Lest, our hearts drunk with the wine of the world, we forget Thee.
Shadowed beneath Thy hand,
May we forever stand,
True to our God,
True to our native land.

JAMES WELDON JOHNSON (1871–1938)

Gwendolyn Magee

This quilt symbolizes hope and is the one quilt in the
series that truly seems to be able to cross all racial,
ethnic, and cultural lines. The beauty of it seems to
strike some inner chord and it resonates with just about
everyone, almost putting some into a meditative trance.

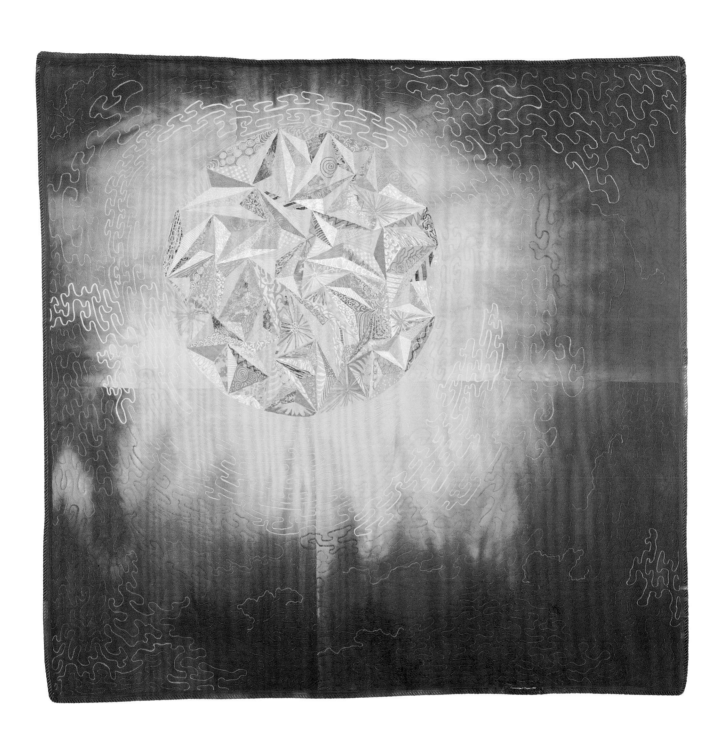

45 **OUR NEW DAY BEGUN** *2000. 70 x 72 inches.*
Machine appliqué and quilted.

L'Merchie Frazier

Central to understanding freedom in America is to understand the sacred journey to it highlighted in the history of the African American captives of/fugitives from slavery and the Underground Railroad. My quest in *Jubilation: Is Freedom Visible?* is to explore and celebrate this question. The quilt, showcasing the Emancipation Proclamation (1863) and General Order No. 3 (1865), which signified the legal end of slavery in America, is one in a series entitled *Quilted Chronicles*. The quilts are based on documents that record historic and political moments significant to African Americans' struggle for freedom.

From right to left, *Jubilation: Is Freedom Visible?* chronicles the sacred journey to freedom with images of Middle Passage slave ships, the dark journey, enslavement, the targeted fugitive (e.g., in the eyes of fugitive Rev. Arthur Cooper), the abolitionists, the Abolitionist Movement, the Civil War, the Emancipation Proclamation, and the question "Is Freedom Visible?" Historical dialogue is expressed by the text, including excerpts from the *Liberator* and *North Star* newspapers, letters, narrative (like that of Equiano), and quotations (such as biblically based passages from Angelina Grimké). All images are hand-dyed and photo images on silk.

The cornerstone of the quilt is the photo image of the First African Baptist Church in Boston, from its earliest days more commonly known as the African Meeting House. The church and its community became a hub of the Underground Railroad, representative of the work done in of other churches and safe houses in

EDUCATION
City College, New York, NY
University of Hartford, Hartford, CT
School of the Museum of Fine Arts, Boston, MA

POSITION
Director of Education, Museum of Afro American History, Boston, MA

SELECTED COLLECTIONS
University of Vermont, Burlington, VT
American Craft Museum, New York, NY
Smithsonian Institution, Washington, DC

SELECTED AWARDS
2001 New England Foundation for the Arts, City of Boston Public Art Award
1999 Best of Boston Poetry Award
1996 Francis X. Merrit/Mary B. Bishop Grant
1994 Lila Wallace–Arts International Fellowship (artist-in-residence in Brazil)

SELECTED EXHIBITIONS
1996 *Spirits of the Cloth: Contemporary Quilts by African-American Artists*, American Craft Museum, New York, NY

SELECTED REFERENCES
Fiberarts, The Magazine of Textiles, March/April 1997.
International Review of African American Art (IRAAA), Hampton University Museum, Vol. II/2, 1994.
Art New England, August/September, 1994.

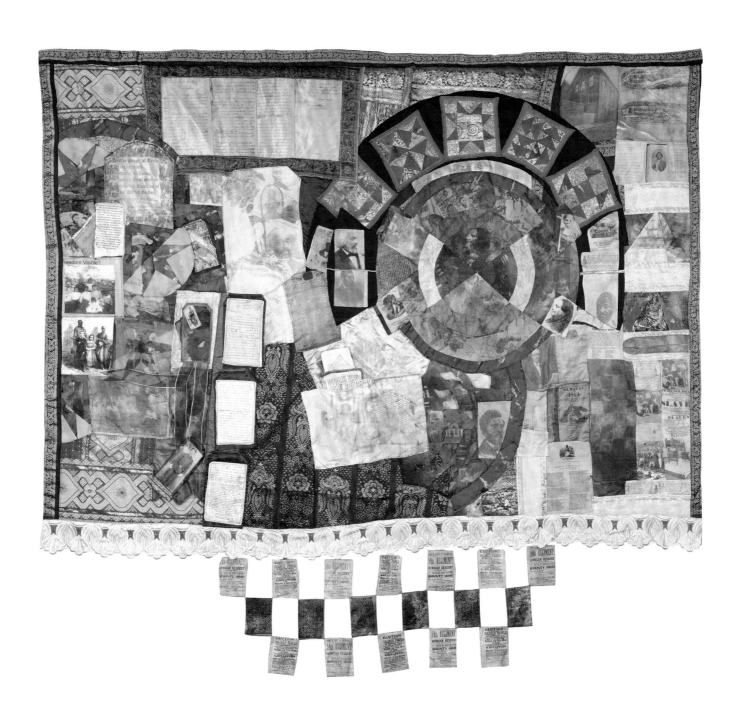

46 **JUBILATION: IS FREEDOM VISIBLE?** *2001.*
80 x 72 inches. Silk, cotton; photo transfer, appliqué,
and machine quilted.

the eighteenth and nineteenth centuries, which contributed significantly to the end of legal slavery in America. Established in 1796, the African Society of Boston provided financial assistance, equal opportunity, and education for its members, a sacred place to assemble and to participate in the anti-slavery movement, to be educated, and to practice religious freedom. The Society and its Beacon Hill community built the African Meeting House in 1806. This building, now owned and operated by the Museum of Afro American History, served as a seat of the abolition movement. It is one of the oldest institutions in the United States built and maintained to document, preserve, conserve, and explore freedom history.

The quilt's layered format features the images of the targeted fugitives, their daring runs, the Underground Railroad escape routes, and quilt codes. The codes served as symbols and signs of communication, signifiers of the sacred geometrical coded languages contained in African American textile and cultural traditions. The arched codes depicted in the quilt provide protection for the fugitive. The pockets in the quilt are meant to encourage the audience to share its knowledge of this little-known history by placing information in the pockets. The "Caution" posters and the 54th Regiment recruitment handbills serve as medicine bags at the bottom of the quilt. The photograph of a post-Civil War African American family taken by nineteenth-century photographer Hamilton Sutton Smith further engages us in the enduring question, "Is Freedom Visible?"

Diane Pryor-Holland

While visiting Ghana during the summer of 2002,
I had an opportunity to visit the slave castle Elmina.
It was a hard journey for so many. Learning how my
ancestors were forced into leaving the very land they
loved, the inhumane conditions of their travel, and the
suffering within the castle walls raised my anger and
hurt to levels I did not know I could experience. The
vision of the "Door of No Return" will be forever etched
in my mind. I wanted to create a healing memorial for
my healing and the healing of all the people that were
enslaved and sent through that doorway.

Working on the piece was very painful in the
beginning because I wanted to create sharp images
of something so horrendous, but it turned out to be a
beautiful new beginning. The colors chosen for this
piece created healing for my soul and those who view
the piece love the way the sting of its original sin is
now removed. That for me brings peace and forgive-
ness. We survived the "Crossing Over" and must never
forget how we got here and how blessed we truly are.

47 **CROSSING OVER** *2002. 33 x 27 inches. Commercial cotton fabric and batting, lace, tulle lace, metallic thread, hand-dyed cotton; hand quilted.*

Denise M. Campbell

A divinely inspired historical account from the Book of Job, believed by many to be the oldest book in the Bible, served as the spiritual inspiration for this first quilt in my *Jemima Series*. "Jehovah-Rophe-God, who heals," restored all that Satan stole from Job. Jemima, whose name means "beautiful as the day," was the eldest daughter of Job's restored life. By His word, God intended Jemima to be remembered as a symbol of beauty and restoration. Yet most Bible scholars and students have not connected this important biblical truth with restoring to beauty the image of black womanhood associated with the name Jemima.

Popular man-made images of Jemima evolved from a grotesque caricature of a black woman slave on a pancake box. In contrast, I have reclaimed Job's Jemima, the beautiful eldest daughter of the wealthiest man in the land, as an elegantly adorned black woman who would surely be served "pancakes wherever she goes." Man's images of Jemima, copyright 1916, have poisoned and bruised the minds of men and women for generations; but God's image of Jemima, copyright circa 2000 BC, is the first and last word on Jemima's true inheritance. This powerful message continues in the border imagery through quilted African Adinkra symbols: "Gye Nyame," literally meaning "Only God," signifying that only God, not humans, makes important decisions; "Duafe," symbol of the wooden comb, which stands for the positive qualities of women: patience, fondness, care; "Aya," the fern, a symbol of defiance, independence, and fearlessness

EDUCATION

1977 BA, Psychology, University of California, Irvine, CA

1979 MA, American University, Washington, DC

Current Doctoral Candidate, Claremont Graduate University, Claremont, CA

POSITION

Special Assistant to the Provost for University Initiatives, California Polytechnic State University, San Luis Obispo, CA

SELECTED REFERENCES

Campbell, Denise M., *"Would the Real Jemima Please Stand Up and Claim Her Inheritance:" A Topography of Artistic Reappropriation* (forthcoming).

-----. "Denise M. Campbell," The Remember Quilt Project Registry, San Luis Obispo: California Polytechnic University, 2000.

Taylor, Daniel, *The Healing Power of Stories: Creating Yourself Through the Stories of Your Life*, New York: Doubleday, 1996.

48 WOULD THE REAL JEMIMA PLEASE STAND UP AND CLAIM HER INHERITANCE? *2003.*
52 x 44 inches. Cotton; hand embroidered, hand appliqué,
and hand quilted.

against negative misrepresentations of black womanhood. Even the quilt label, the "Fihankra," which literally means "house that is safe," a symbol of security and peace, is a reminder of God's faithfulness. In what I call a "sermon quilt," I reclaim God's truth about the name, image, and inheritance of Jemima, revealing the uncelebrated significance of one of the most widely told biblical stories of patience, faith, healing, and restoration.

JOB 42:12–15 *The LORD blessed the last part of Job's life even more than he had blessed the first. Job owned fourteen thousand sheep, six thousand camels, two thousand head of cattle, and one thousand donkeys. He was the father of seven sons and three daughters. He called the oldest daughter Jemimah, the second Keziah, and the youngest Keren Happuch. There were no other women in the whole world as beautiful as Job's daughters. Their father gave them a share of the inheritance along with their brothers.*

SPECIAL OFFER

Look on the tops of packages
for the coupon telling how to get
the entire Jemima Rag Doll Family
for the little ones – Includes
Father Job, Jemima, and Sisters
Kezia and Keren-happuch

Marla Jackson

The quilt depicts an African American angel with inspirational verses taken from the book of Proverbs. The idea came to me as I talked to my grandmother about her love of God and the way she extended herself for her family. My grandmother was a wonderful quilter and she devoted herself to many tasks. I watched her every move with admiration. When I was a little girl I asked how I could follow in her footsteps and she answered, "Baby, all you have to do is look in the Bible. It's laid out for you in Proverbs. Let this be your guide and you will never go wrong."

Proverbs 31.13, 31.19, and 31.31 are embroidered to the angel's left. The passage beneath the basket reads: "When combining needlework with prayer a quilter catches a glimpse of God who stitches the fabric of our lives with his plans and purposes."

The angel holds in her hands the following text: "Quilts wrap our hearts in warm emotions. They represent time, energy and planning. The hours required to create a quilt offer plenty of opportunity to think about the person for whom it is intended, when combining needlework with prayer, a quilter catches a glimpse of the love of God who stitches the fabric of our lives with his plans and purposes for our good and not our destruction."

PROVERBS 31.13 *She keeps herself busy making wool and linen cloth.*

PROVERBS 31.19 *She spins her own thread and weaves her own cloth.*

PROVERBS 31.31 *Give her credit for all she does. She deserves the respect of everyone.*

EDUCATION
2001 Stafford Career Institute, Certificate in Interior Decorating

POSITION
Residential Supervisor, Quilting Instructor, Cottonwood, Inc.

SELECTED AWARDS
2003 Mini Fellowship, Kansas Arts Commission, Topeka, KA

SELECTED EXHIBITIONS
2003 *Voices of the Cloth: African American Quilt Exhibit*, Watkins Community Museum of History, Lawrence, KS (curator)
2002 *Underground Railroad Exhibition*, Hallmark Corporate Gallery, Lawrence, KS
2001 *Truth of Soul*, Watkins Community Museum of History, Lawrence, KS

SELECTED REFERENCES
Biles, Jan, "Stitching an African-American Legacy," *Lawrence Journal World*, October 28, 2001.

Merkel-Hess, Matt, "Quilts Detail Artist's Connection to Slavery," *Lawrence Journal World*, December 10, 2001.

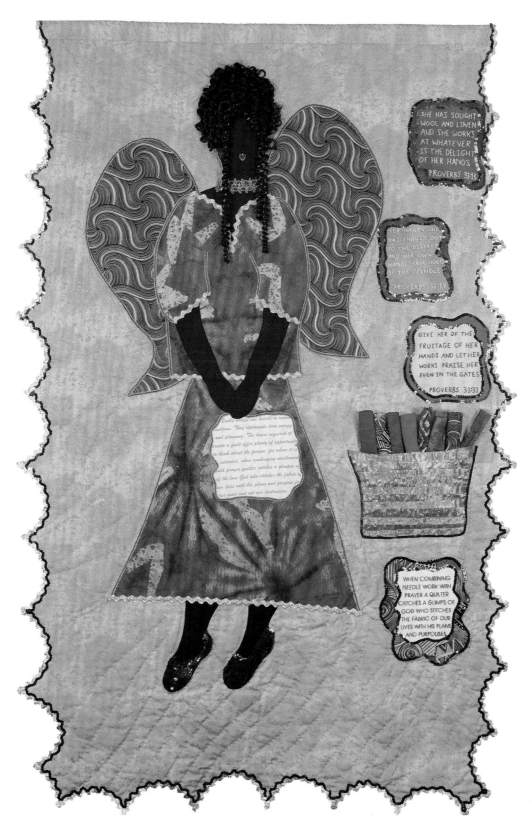

49 **ANGELIC WATCH** *2002. 64 x 40 inches. Cotton, metallic rick rack, sequins, beads, buttons; hand appliqué and quilted.*

Alice Beasley

Since 1988, I have been making "portrait" quilts in which I achieve the effects of light and shadow and the modeling of the figures using only machine appliquéd commercial fabric and thread.

The image that inspired *Behind the Barricade* was the ubiquitous yellow police tape that we see at every accident scene and on every televised police drama. When the Oklahoma City bombing occurred, I stood like everybody else, transfixed by the television, watching the same pictures over and over as the building burned and collapsed, and as children were brought out, lifeless, inert. When I was invited to make a quilt to memorialize this tragedy, my first thought was to picture the victims, perhaps that baby cradled by the fireman who brought her from the ruins. But as I thought about it, I decided that I wanted to adopt a more universal theme, recognizing the unspoken victims, the people who stood behind the barricade of our televisions, watching our society and innocence transformed. I used the metaphor of the familiar yellow police tape to show our helpless separation from the pictures we were watching. I wanted those who see this quilt to see themselves and realize that we are people of many ages, races, beliefs, and cultures, but in times of national tragedy, we stand together in shock, in silence, in reverence, in prayer, transfixed behind a "virtual" police barricade, watching terror unfold on television, comforting our children, and trying to explain. Sadly, this piece turned out to be far more universal than I had intended. It is just as relevant to the 9/11 tragedy as it is to the Oklahoma City bombing.

EDUCATION
1966 BA, Marygrove College, Detroit, MI
1973 JD, University of California at Berkeley, Boalt Hall, Berkeley, CA

POSITION
Partner with the law firm of Erickson, Beasley, Hewitt & Wilson LLP, Oakland, CA

SELECTED AWARDS
2001 Juror's Choice Award and People's Choice Award for *Tuesday in the Park with George*, Gallery 510 Fiber Arts, Decatur, IL.

Nova Gallery's Award of Excellence for "Cool Blue: Depth Perception," Gallery 510 Fiber Arts, Decatur, IL.

SELECTED EXHIBITIONS
2003 *El Arte de Coser Arte* (The Art of Sewing Art), Museum of the Americas, Madrid, Spain

2001 *Communion of the Spirits*, Natural History Museum of Los Angeles County, Los Angeles, CA

2000 *Women of Taste: A Collaboration Celebrating Quilt Artists and Chefs* (traveling)

Roots of Racism: Ignorance and Fear, Vertigo Studios, Memphis, TN (traveling)

Solo Exhibition, Thirteen Moons Gallery of Contemporary Art Quilts, Santa Fe, NM

1999 *Go Figure*, San Jose Museum of Quilts and Textiles, San Jose, CA

1997 *Daughters of Harriet Powers*, Museum of African American Art, Tampa, FL

1996 *Sewing Comfort Out of Grief: The Oklahoma City Children's Memorial Art Quilts* (traveling)

SELECTED REFERENCES
Bilik, Jen, ed., *Women of Taste: A Collaboration Celebrating Quilt Artists and Chefs*, Lafayette, CA: C&T Pub., 1999.

"East Bay Attorney/Quilter Finds Peace in Piecing," *California Daily Journal*, June 12, 2000.

"Sewing Comfort Out of Grief: The Oklahoma City Children's Memorial Quilt Exhibition," *Art Quilt Magazine*, Issue No. 8 (1997): 16.

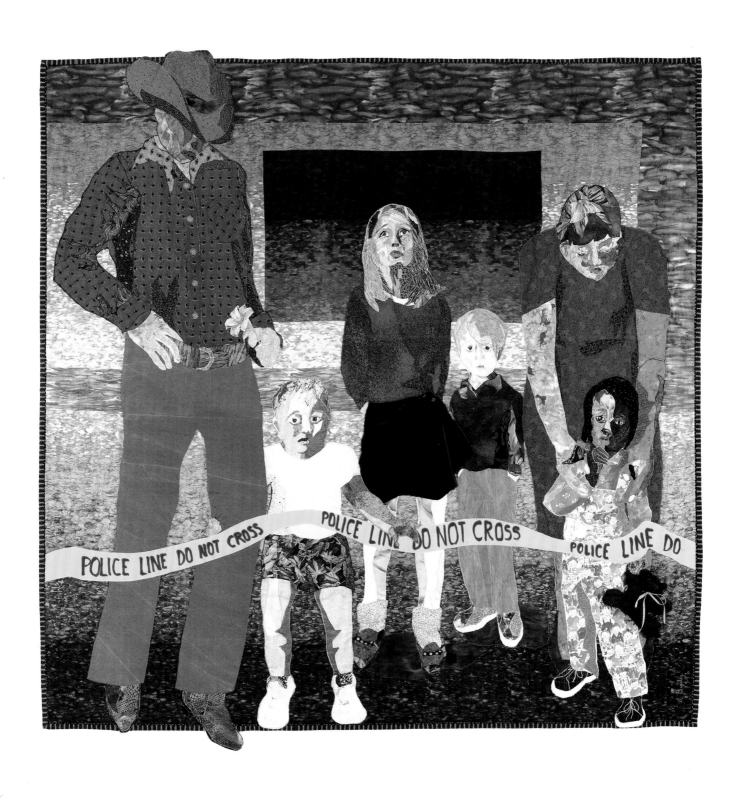

50 BEHIND THE BARRICADE *1996. 62¼ x 61¼.*
Cotton; machine appliqué.

Viola Canady

I made my black angels after my grandson asked the question, "Who ever saw a black angel?" In all of his young life, all the angels he'd ever seen, in church, magazines, books, and television, were white. He thought that all angels must be white and God didn't make black angels. I chose to make angels in the image of my people. I was invited to hang one of my angels at a monastery in Georgetown, whereupon I received a call from one of the employees asking why my angel was black. I thought it a ridiculous question. Didn't God make all peoples of the world? Are all the world's citizens white? I think not. It's a sad commentary on the state of the world when folks believe that an angel can only be a white. Later, I received a call from a priest at the monastery telling me he was happy to see my black angels.

PSALM 91.11–12 *God will put his angels in charge of you to protect you wherever you go. They will hold you up with their hands to keep you from hurting your feet on the stones.*

POSITION
Founder, Daughters of Dorcas and Sons, Washington, DC

SELECTED COLLECTIONS
Charles and Sumner School Museum and Archives, Washington, DC

Franklin School Museum, Washington, DC

SELECTED AWARDS
1990 Individual Fellowship, Washington, DC, Commission on the Arts and Humanities

SELECTED REFERENCES
Freeman, Roland L., *A Communion of the Spirits: African-American Quilters, Preservers, and Their Stories*, Nashville, TN: Rutledge Hill Press, 1996: 176–77.

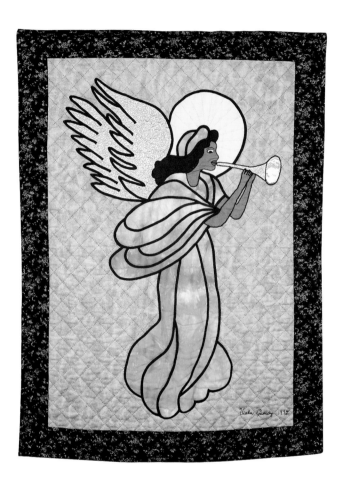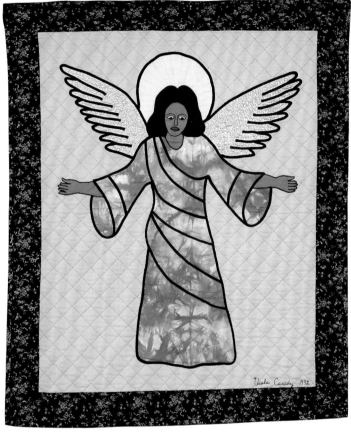

51 **ANGEL 1** *1992. 36 x 26 inches. Cotton.*

52 **ANGEL 2** *1992. 35 x 29 inches. Cotton.*

Peggie Hartwell

Thank you, "ancestral grandmother," for the legacy you left for us: two glorious Bible quilts, one in the Museum of Fine Arts, Boston, the other in the Smithsonian Institution, Washington, DC. Your artistry inspires us. Your vision allows us to see what your eyes could not behold. Your quilts not only connect quilter to quilter, but also culture to culture. Your messages of faith, hope, and redemption embrace the spirit of humanity, such gracious gifts to bestow on your "ancestral" grandchildren and fellow artists. We are indeed humble.

I show Harriet Powers (1837–1911) at the center of the quilt surrounded by my interpretations of her imagery. I created *Ode to Harriet Powers* to honor this wonderful quilt artist. During and after my research I felt so connected to her that she became a kindred spirit for me. I could think of no better way to honor this master artist than to create a quilt commemorating her and her work. I made the quilt with the intention of having it on display in as many exhibitions as possible so that Powers' legacy would be revealed to many people. I made the quilt with the knowledge that it might be the closest I would ever get to placing a tombstone on her grave, the search for which sparked my initial research.

The block at the top left depicts the Crucifixion of Christ between the two thieves, when the sun went into darkness, with Mary and Martha weeping at his feet and the blood and water running from his right side. Below it, rich people Bob Johnson and Kate Bell of Virginia are shown with the independent hog Betts that ran 500 miles

EDUCATION

1978 BA, Theater, Queens College, New York, NY

1992 Lifetime Career Schools, Certificate of Doll Making and Repair, Archbald, PA

1998–99 Fashion Institute of Technology, New York, NY

SELECTED COLLECTIONS
Miami Children's Museum, Miami, FL

Middlebury College Museum of Art, Middlebury, VT

American Craft Museum, New York, NY

National Afro-American Museum and Cultural Center, Wilberforce, OH

Children's Museum, New York, NY

SELECTED AWARDS
1999 Lower Manhattan Cultural Center Recipient

1996 National Quilting Association Recipient

1995 Empire State Craft Alliance Grant Recipient

SELECTED EXHIBITIONS
2003 Auburn University, Auburn, AL

2002 National Civil Rights Museum, Memphis, TN

2001 Museum of Afro American History, Boston, MA

1999 *Spirits of the Cloth: Contemporary Quilts by African American Artists*, American Craft Museum, New York, NY

1998 *In the Spirit of the Cloth*, Museum of Fine Art, Spelman College, Atlanta, GA

1997 Museum of African American Art, Tampa, FL

1996 *Spirit of the Cloth: African-American Story Quilts*, Wadsworth Atheneum, Hartford, CT

SELECTED REFERENCES
Freeman, Roland L., *A Communion of the Spirits: African American Quilters, Preservers, and Their Stories*, Nashville, TN: Rutledge Hill Press, 1996: 59, 166-69, 317.

Hicks, Kyra E., *Black Threads: An African American Quilting Sourcebook*, Jefferson, NC: McFarland & Co., 2003.

Mazloomi, Carolyn, *Spirits of the Cloth: Contemporary African-American Quilts*, New York: Clarkson Potter/Publishers, 1998: 60, 86–87, 134, 182.

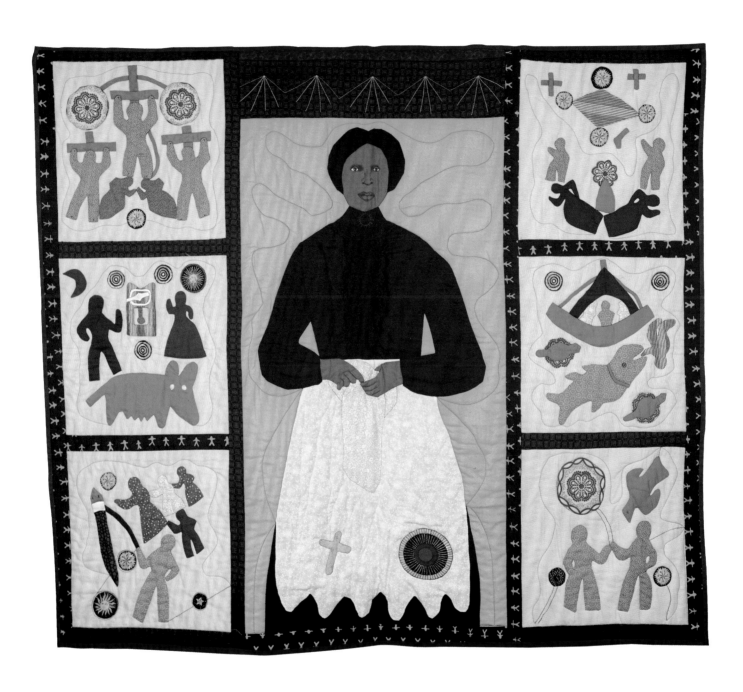

53 ODE TO HARRIET POWERS *1995. 42 x 48.*
Cotton; hand painting, hand appliqué, machine pieced,
hand and machine quilted.

from Georgia to Virginia. At bottom left are depicted Moses and the serpent, and women bringing their children to be healed.

At the top right, Job is shown praying for his enemies, surrounded by his crosses and coffins. The middle block portrays Jonah and the whale, and the Baptism of Christ is shown at the bottom right, with the spirit of God descending and resting upon his shoulder like a dove. The six scenes on the quilt are taken from Powers' two Bible quilts. Quilt historian Cuesta Benberry sent me an out-of-print pattern book that contained Powers' patterns.

The blocks I chose represent hope, deliverance, redemption through prayer, and meditation, which are principals I believe Powers followed. I cannot imagine an artist designing these blocks without knowledge of the Bible. The fact that it has been documented that Powers could not read or write only illustrates how deeply religious she was.

Checklist of the Exhibition

**I. Sacred Moments:
From Scripture to Cloth**

1 **Proverbs 7.4** *2003.*
Adriene Cruz
*30 x 18 inches. Cotton and metallic
fabrics, brass and beaded ornaments,
cowrie shells, lemon verbena.*

2 **Palm Tree of Deborah** *1995.*
Adriene Cruz
*36 x 38 inches. Cotton, acrylic paint,
beads, shells.*

3 **Eve's Garden** *2001.*
Peggie Hartwell
*42 x 38 ½ inches. Cotton, rayon, silk,
cotton and metallic threads; machine
embroidered, machine quilted.*

4 **Hagar and Her Children** *2000.*
Peggie Hartwell
*64 x 51 inches. Silk, rayon, velvet,
brocade, cotton and metallic threads;
machine appliqué, machine quilted,
hand embroidered.*

5 **The Burning Bush** *2003.*
Michele David
*40 ½ x 40 inches. Cotton; machine
appliqué and quilted.*

6 **The Creation: And God Created
the Earth** *2003.*
Michele David
*47 x 55 inches. Commercial cotton fabrics,
silk leaves, tulle, cotton and metallic
threads; appliqué and machine quilted.*

7 **Peace at Christ's Birth** *1998.*
Cynthia H. Catlin
*48 x 40 inches. Cotton; machine
pieced and quilted.*

8 **The Annunciation: Be It Unto
Me According to Thy Word** *2003.*
Theresa Polley-Shellcroft
*75 x 45 inches. Cotton, beads, sequins;
appliqué and hand quilted.*

9 **Christ Bearing the Cross** *2003.*
Michael Cummings
*91 x 71 inches. Cotton, linen; machine
appliqué and quilted.*

10 **A Place for You** *2002.*
Phyllis Stephens
92 x 60 inches. Cotton; appliqué, quilted.

11 **A Mother's Vigil** *2003.*
Marlene O'Bryant-Seabrook
*72 x 52 inches. Hand-dyed cotton,
commercial cottons, nylon netting,
yarn; machine pieced, hand appliqué,
and quilted.*

12 **Stirred Up** *2003.*
Cathleen Richardson Bailey
*21 x 34 inches. Cotton, acrylic paint,
glitter, sequins and beads; appliqué,
stump work, hand embroidery.*

13 **And a Time to Dance** *2003.*
Myrah Brown Green
*87 x 60 inches. Cotton; machine appliqué
and quilted.*

II. Bearing Witness

14 **Woman I Am** *2002.*
Yvonne Wells
*101 x 69 inches. Cotton; hand appliqué,
hand quilted.*

15 **Spirit Women** *2003.*
Gwendolyn Aqui
*34 x 31 inches. Cotton; machine appliqué,
machine quilted.*

16 **Tranquility** *1998.*
Anita Knox
*60 x 54 inches. Cotton, silk, buttons, beads;
hand and machine appliqué, hand and
machine quilted.*

17 **Mother Dear, Our Matriarch** *2003.*
Sherry Whetstone-McCall
*37 x 54 inches. Cotton, beads, shells;
machine appliqué and quilted.*

18 **Church Ladies** *2002.*
Michele David
*28 x 28 inches. Commercial cotton fabrics,
cotton thread; machine appliqué and
quilted.*

19 **Color Him Father** *1998.*
Barbara G. Pietila
*53 ¼ x 58 inches. Cotton; hand and
machine appliqué, hand and machine
quilted.*

20 **First Born** *2002.*
Marla Jackson
*77 x 54 ½ inches. Cotton, beads, plastic,
canvas, wooden cutouts; hand appliqué,
hand and machine quilted.*

21 Her Coat of Arms *1999.*
Diane Pryor-Holland
49 x 70 inches. Cotton, beads, cowrie shells; hand appliqué and quilted.

22 Threads of the Past, Inspiration for the Future *2003.*
Dindga McCannon
54 x 56 inches. Silkscreen, acrylic paint; machine embroidered, machine quilted.

23 Sisters in the Spirit *2003.*
Dindga McCannon
40 x 42 inches. Cotton, acrylic paint, antique mirrors, rayon and metallic threads; appliqué and machine quilted.

III. Hope: The Anchor of Our Souls

24 Wandering Faces Facing Secrets Seeking Wonder *2000.*
Frances Hare
56 x 68 inches. Cotton; collage, machine quilted.

25 The Redemption *2003.*
Viola Burley Leak
94 x 55 inches. Cotton, silk, tulle, metallic cloth; quilted.

26 Lift Up Thine Eyes Unto Heaven *2003.*
Theresa Polley-Shellcroft
29 x 22 inches. Cotton, beads, sequins; appliqué and hand quilted.

27 There Are No Mistakes *1998.*
Tina Williams Brewer
53 x 48 inches. Cotton, silk; hand appliqué and quilted.

28 Witness *2001.*
Adriene Cruz
39 x 19 inches. Cotton and metallic fabrics, mirrors, cowrie shells, glass beads, crushed lavender.

29 No Turning Back *1995.*
Yvonne Wells
96 x 78 inches. Cotton; hand appliqué, hand quilted.

30 Keys to the Kingdom *2002.*
Yvonne Wells
98 x 62½ inches. Cotton, polyester; hand appliqué and quilted.

31 The Lord's Prayer Quilt *2003.*
Kyra E. Hicks
96 x 75 inches. Cotton; machine appliqué, machine quilted.

32 Prayers and Dreams *1998.*
Kyra E. Hicks
84 x 62 inches. Cotton; machine appliqué and quilted.

33 Prayer Closet *1999.*
Zene Peer
112 x 47 inches. Cotton, metal, glass, bone, shell beads; hand embroidery, quilted.

34 Healing Spirit II *2003.*
Ed Johnetta Miller
51 x 43 inches. Cotton; machine pieced and quilted.

35 Pray in the Spirit *2003.*
Cynthia H. Catlin
41 x 53 inches. Cotton and metallic fabrics, cotton, rayon, and metallic threads, beads; machine pieced and quilted.

36 He Restoreth My Soul *2003.*
Sandy Benjamin-Hannibal
57 ⅛ x 74 ⅜ inches.

IV. Blessed Are the Piece Makers

37 At the Cross *2003.*
Myrah Brown Green
86 x 59 inches. Cotton; machine appliqué and quilted.

38 Dance of Praise *2002.*
Trish Williams
42 x 56 inches. Cotton; appliqué, hand and machine quilted.

39 Make a Joyful Noise Unto the Lord *2002.*
Cynthia Lockhart
42 x 30 inches. Cotton, silk, beads, acrylic paint; machine appliqué and quilted.

40 Two Ministers *2003.*
Dindga McCannon
43 x 41 inches. Cotton, acrylic paint; machine quilted.

41 Communion Robe and Cross *2003.*
Cleota Proctor Wilbekin
49 x 56 inches. Cotton, lace.

42 Take My Brother Home *1999.*
Michael Cummings
92 x 52 inches. Cotton, acrylic paint; machine appliqué, machine quilted.

43 Bridge Over Troubled Waters *2002.*
Phyllis Stephens
72 x 44 inches. Cotton; appliqué, quilted.

PHOTOGRAPHIC ACKNOWLEDGMENTS

PAGE 28
Collection of Dr. Marlene O'Bryant-Seabrook

PAGE 29
National Museum of American History, Smithsonian Institution

PAGE 30
Museum of Fine Arts, Boston, Bequest of Maxim Karolik 64.619; photograph ©2003 Museum of Fine Arts, Boston

PAGE 35
Gift of the Howard Tubman Education Trust to the permanent collection of the Robert W. Woodruff Library, Atlanta University Center, Atlanta, Georgia; photograph courtesy of the Robert W. Woodruff Library.

PAGE 37
©2003 Roland L. Freeman

PAGE 38
Photograph by Theobald G. Wilson

PAGE 163
Photograph by Jim Jacobs

PAGE 147
"Lift Every Voice And Sing"
(written by J. Rosamond Johnson, James Weldon Johnson)
Used by permission of Edward B. Marks Music Company

All other images
©2003 The Gallery at the American Bible Society / Gina Fuentes-Walker

COVER IMAGES

From left to right:

Anita Knox, *Tranquility*, 1998

Denise M. Campbell, *Would the Real Jemima Please Stand Up and Claim Her Inheritance?*, 2003

Marlene O'Bryant Seabrook, *A Mother's Vigil*, 2003

Myrah Brown Green, *At the Cross*, 2003

Viola Burley Leak, *The Redemption*, 2003

Large detail:

Michael Cummings, *Christ Bearing the Cross*, 2003